Charles Simonds

Museum of Contemporary Art, Chicago

November 7, 1981–January 3, 1982

This exhibition has been supported by the Museum's Contemporary
Art Circle and by grants from the National Endowment for the Arts,
a federal agency and the Illinois Arts Council, a state agency.

Exhibition Tour

Museum of Contemporary Art, Chicago
November 7, 1981-January 3, 1982

Los Angeles County Museum of Art
January 28-March 21, 1982

Fort Worth Art Museum
April 13-May 30, 1982

Contemporary Arts Museum, Houston
June 21-August 15, 1982

Photography Credits

Rudolph Burckhardt: Cover ill.; Pls. 12-14, 18, 20,
26, 32, 33, 35-39, 42-46.
Linda Cathcart: Pl. 10.
Tom Crane: Pl. 40.
eeva-inkeri: Pls. 15, 16.
Jacques Faujour: Fig. 3; Pls. 8, 9, 17.
Gu Yang: Fig. 2.
Kunsthaus Zürich: Pl. 11.
Museum Boymans-van Beuningen: Fig. 1.
Nathanson: Pl. 3.
Charles Simonds: Pls. 1, 4-7, 21, 22, 24, 25, 27-31.
Stedelijk Museum: Pl. 23.
David Troy: Pl. 2.
Tom Van Eynde: Pls. 19, 34, 41.

Library of Congress Cataloging in Publication Data
Main entry under title:
Charles Simonds: Museum of Contemporary Art,
 Chicago, November 7, 1981-January 3, 1982.
 1. Simonds, Charles—Exhibitions. I. Simonds,
Charles. II. Museum of Contemporary Art (Chicago,
Ill.)
N6537.S55A4 1981 709'.2'4 81-16891
ISBN 0-933856-09-1 AACR2

Designed by Michael Glass Design, Chicago, Illinois.

Typeset in Trump by Dumar Typesetting, Inc., Dayton, Ohio.

3,000 copies were printed on Warren Lustro Offset Enamel
by Eastern Press, New Haven, Connecticut.

Cover illustration: *Picaresque Landscape,* 1976, detail.
Installation at the Museum of Modern Art, New York.
Collection of the artist.

Table of Contents

Introduction

Reunited for this exhibition, the 12 works that comprise the sequence *Circles and Towers Growing* were conceived in 1978, completed the following year, and shown soon after at the Wallraf-Richartz Museum in Cologne and the Nationalgalerie, Berlin.[1] Subsequently, only parts of the whole were exhibited.[2] This is the first showing of this extraordinary cycle in the United States, and, with the addition of a new cycle of three pieces constructed for this exhibition, the most extensive opportunity yet to see the work of Charles Simonds.

That this is so is because only some aspects of the artist's work are intended for viewing in museums. Although Simonds has acquired an art world following over the last decade, much of his time and energy has been devoted to temporary "Dwellings," tiny structures of unfired clay bricks inconspicuously inserted with tweezers into crumbling walls, onto ledges and window sills in neighborhoods where the concerns of both museums and the art market are worlds away. Over 300 Dwellings and ritual structures for his imaginary race of migrating "Little People" have been built all over the world since the winter of 1971: from the Lower East Side of New York (over 200 alone), to California, the British Isles and Western Europe, to Australia and China. A few have survived, but most have succumbed to the elements, children's games, or efforts to take them home. Consequently, there is no large body of portable works from which to assemble an exhibition. There has been little opportunity to view the work except for one or two pieces or a single installation at a time. The result has been to create a quasi-legendary aura about the work, so that Simonds's Dwellings survive primarily as an oral tradition, as memory. This situation the artist willingly accepts as a consequence of the way he has chosen to work.

Simonds's biography is likewise by choice limited to an outline of events. He was born November 14, 1945 in New York, the younger son of two Vienna-trained psychoanalysts, and raised on the Upper West Side. His grandparents had immigrated to the United States from Russia. He attended the New Lincoln School in Manhattan, then the University of California at Berkeley where he majored in art, receiving his Bachelor of Arts degree in 1967. He married in 1968 and attended Rutgers University, New Brunswick, New Jersey, earning his Master of Fine Arts in 1969. From 1969 to 1971 he taught at Newark State College, having moved back to New York where he shared a building at 131 Chrystie Street with artists Gordon Matta-Clark and Harriet Korman. He began in 1970 his ritual Mythologies in the Sayreville, New Jersey claypits and other more impromptu street activities with Matta-Clark around New York and the vicinity. At this time the first Dwellings were made outdoors. From 1971 to 1972 Simonds lived in a building on 28th Street owned by his brother, who managed rock bands which occupied the other floors. First in Jeffrey Lew's loft at 112 Greene Street and later at 98 Greene Street, Simonds joined friends in informal, experimental art activities and performances. In 1971 he met art historian and critic Lucy Lippard with whom he has lived on Prince Street since 1972. In that year he came to know Robert Smithson. During the 1970s, as his work became known beyond a small group

of friends and critics, Simonds traveled widely as a visiting artist or participant in group exhibitions. Since the mid-1970s he has been included in most of the major international and national invitational exhibitions and his works have entered the permanent collections of museums here and abroad. He has recently started working at a new studio on East 22nd Street and still conducts his affairs without a gallery or agent. As this catalogue goes to press, he is exploring the possibilities of a visionary, environmental museum of natural history.

This book which accompanies the exhibition is an effort to begin to assemble the photographs and texts which will make it somewhat easier for future authors to deal with the diversity of Simonds's work, most of which has not even been photographed or otherwise documented. (There are also various kinds of private works which he makes for himself and friends which have not been considered here.) The photographs are arranged according to Simonds's categories and the section headings are based upon his written descriptions. The categories are not mutually exclusive; it would have been equally possible to group certain projects together as "Cosmological" and "Organic Architectures," an option which the artist may exercise in the future.

The three essays reflect the variety of responses that Simonds's Little People have elicited over the last decade. Simonds's work first appeared in the charged, politicized context of the early 1970s, which often focused upon the implications of his street works with regard to the conventions of the New York art world. Subsequent critiques questioned the apparent contradictions of his also making unique, salable works. John Beardsley's essay focuses on the question of the public works, while Daniel Abadie's evokes the myriad associations of fantasy and reality that we encounter through the range of Simonds's activities as an artist. The third essay alternates between a reading of the sculptures as objects and an introduction to some of the diverse ideas which contribute to their meaning; the notes can be read separately as suggestions for further exploration. The *Commentaries* are a personal tour of *Circles and Towers Growing*, again concentrating on the presence of the sculptures themselves in the exhibition. Reprinted in its entirety is Simonds's text *Three Peoples*, which relates the histories and beliefs of the Little People.

<p style="text-align:center">* * *</p>

Since the Fall of 1979 when arrangements for the first United States showing of Charles Simonds's *Circles and Towers Growing* were initiated, this exhibition and book have required the ongoing efforts of the entire staff of the Museum of Contemporary Art. I would like particularly to acknowledge the assistance of Robert Tilendis, Mary Jane Jacob, Mary Braun, Lynne Warren, and Ted Stanuga, who have made it possible for me to develop the exhibition in the midst of other responsibilities. Terry Ann R. Neff, editor of the catalogue, and Michael Glass, designer, are to be thanked for organizing the written and visual information to reflect as much as possible the flow, both formal and conceptual, of the artist's interconnected works. Many of these are not documented or are referred to in relatively inaccessible local newspapers or foreign periodicals. The selected bibliography was drawn in part from the artist's own files; the initial ordering and listing of the material was facilitated

by Clive Phillpot, Librarian of the Museum of Modern Art, and done by Donna Kehne, MOMA intern. Rudolph Burckhardt kindly agreed to photograph the pieces in New York; Tom Crane shot the piece in Bryn Mawr, Pennsylvania; and Tom Van Eynde photographed the Paris and Chicago sculptures.

I am most grateful to my colleagues for their essays, which discuss with knowing grace some of the central issues that Simonds's work raises and that have been raised around it: Daniel Abadie, Curator of the Musée de l'Art Moderne, Centre Pompidou, Paris, one of Simonds's earliest admirers whose exhibitions, acquisitions, and publications introduced the work to a European audience; and John Beardsley, Adjunct Curator at the Corcoran Gallery of Art, Washington, D.C., and organizer of the "Probing the Earth" exhibition, in the catalogue of which (and in other essays) he has discussed the "public" and "private" works of the artist.

Exhibitions seldom simply happen any longer without extensive financial aid. The timely and generous support of the National Endowment for the Arts through the Aid to Special Exhibitions category of the Museum Program has literally made possible this opportunity to see and document the work of an extraordinary artist. We are also grateful to the Illinois Arts Council for this and past funding for contemporary art. My thanks as well to colleagues and to the Boards of Trustees of those museums participating in the nationwide tour, and particularly to the MCA's own Contemporary Art Circle, which has designated "Charles Simonds" as the third annual exhibition to receive its most welcome and substantial support. To the lenders who have generously agreed to share the pleasure of their Circles and Towers with a larger audience for a period of nearly two years, we are most grateful.

In conclusion, my thanks to Charles Simonds, whose art, and enthusiasm for this project, have made working on it a great pleasure for all of us.

John Hallmark Neff, *Director*

Footnotes

1
Wallraf-Richartz Museum, Cologne, March 15-April 15, 1979; Nationalgalerie, Berlin, May 3-June 10, 1979.

2
Numbers 9 and *11* were shown in a DAAD artists exhibition in Berlin, December 8, 1978-January 14, 1979, before the sequence as a whole was exhibited. *Numbers 1-9* were shown at the Musée de l'Abbaye Sainte-Croix, Les Sables-d'Olonne (Vendée), France, June 30-July 31, 1979. *Numbers 1-8* were then shown in Paris at the gallery of Baudoin Lebon, September 25-October 22, 1979. Four of the Circles (*Numbers 4, 5, 7,* and *8*) were shown at Dartmouth College, Hanover, New Hampshire, where Simonds was visiting artist-in-residence, April 25-May 25, 1980; and two of the cycle (*Numbers 6* and *10*) were part of Simonds's representation in the "Pier + Ocean" exhibition in London, May 8-June 22, 1980 and Otterlo, July 13-September 8, 1980.

Charles Simonds's Engendered Places: Towards a Biology of Architecture

By John Hallmark Neff

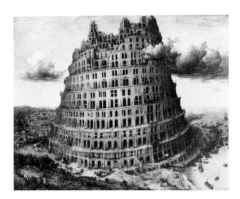

Charles Simonds has been exploring his imaginary civilization of Little People for over ten years—first privately in his studio, then publicly in street pieces, and now increasingly in works which combine aspects of both, in installations or cycles of portable works intended to be seen by people who visit museums. At the same time Simonds continues to make his temporary Dwellings out in the community, while pursuing opportunities for developing his art in new directions through permanent installations in public buildings and private homes. He directs his energies (in a way both obsessive and remarkably unassuming) to working out the most promising of limitless possibilities open to his tiny, imagined culture. Every aspect of his work seems to be another means by which to understand the Little People's ways.

The films in which Simonds has collaborated, for example, make his essentially private rites available to more people than could have attended them in person and also serve "as the records of rituals belonging to the underlying mythology of the Little People."[1] Miniature dwellings and the full scale projects they inspired (such as *Niagara Gorge*, pl. 24, and *Growth House*, pl. 28) make it possible for us to share Simonds's involvement and concern with the facts of habitation, how people live and "how this affects the structures in which they live: with the way people's beliefs are reflected in what they build."[2] In the process we may wonder whether it is we or the constructions that have changed in size, but for Simonds they are all one and the same: there is, he says, only one scale in his mind, "the scale of my vision."[3] He projects himself into each of his works regardless of actual physical dimensions, whether literally to re-enact the Little People's rituals as in the full-scale works, or to invest them with his imagination. Each detail is a living place in which he has been, spent time, and come to know well.[4] And in the process the very notions of "public" or "private" have become so blurred as to beg

Figure 1. Pieter Bruegel the Elder (Flemish, c. 1525/30-1569).
Tower of Babel. Panel; 60 x 74.5 cm (23⅜ x 29⁹⁄₁₆ in.)
Museum Boymans-van Beuningen, Rotterdam (inv. no. 2443).

the question, just as formal analysis alone can only inadequately account for what we feel his landscapes and architectures actually mean. The genesis of *Circles and Towers Growing* (pls. 32-43), although more complicated than most, reflects Charles Simonds's working methods for his art as a whole, the objects as well as the underlying ideas.

One can make the case that each of his pieces, whatever its size, in itself implies the entirety; that each part of the sequence (an open-ended, expanding class as opposed to the closed grouping of a series)[5] deals only with the same work in a different moment. The elaboration of the idea into various landscapes, and new kinds and combinations of structures, enriches our understanding but is, strictly speaking, conceptually unnecessary. Each additional piece, however, adds to the possibility of new audiences and variations through which one might be better able to enter into Simonds's art. As Simonds said regarding *Circles and Towers Growing*, "Nothing but time prevents me from going back to fill in all the betweens. Even in a microsecond there are thousands of ideas for different states between the 12 actual works."[6] In fact, the cycle can be read as several cycles reading at different speeds, laterally as well as in linear branches (see below, *Circles and Towers Growing, Commentaries*). Given the circumstances of its making, this should not be surprising.

The cycle came into being at a time when Simonds was in a position to consolidate a busy year of work. While in Berlin in 1978, taking part in the international artist-in-residency program known as DAAD (Deutscher Akademischen Austauschdienstes), Simonds built nine of the cycle almost entirely in numerical order, the Circles (*Numbers 1-5*), then the Towers (*Numbers 7-10*). The final two Towers (*Numbers 11* and *12*) were built in the fall of 1978 when Simonds returned to his underground studio at 152 Wooster Street, New York. The cycle was completed by the addition of another Circle (*Number 6*), which Simonds literally removed from his room-sized 1976 installation *Picaresque Landscape* (cover ill.), then stored in 23 sections in an adjoining room. This piece was itself a variant of an earlier portable object, the important 1972 *People Who Live in a Circle* (pl. 14). Simonds decided simply to use the variant once again rather than build a third version.[7] These three "New York" pieces were then sent together to Germany to join the nine "Berlin" works to unite the cycle physically for the first time.

The clay for the nine pieces made in Germany came from the recycled " \triangle " installation which had filled a medium-sized upper gallery in the Museum Fridericianum in Kassel during "Documenta 6" in 1977 (pl. 21). Colors ran the spectrum—black, gray-green, red, yellow-orange, yellow, and pink. At the conclusion of the summer-long exhibition, the landscape and its intricate structures were reduced to raw clay and shipped to the artist in Berlin. In addition to the multicolored clays from near Kassel there is also in the *Circles and Towers Growing* a yellow clay from Berlin and the red and gray clay from Simonds's primary source in Sayreville, New Jersey. The sand also came from near Kassel and the various sticks, chicken bones, shells, pebbles, or other materials from friends (who are always on the lookout for tiny specimens of all sorts) and the artist's own far-flung travels.

Unlike clay, the role of color in Simonds's sculpture, often rich and complex color, has been little discussed, although there is no critical question here of his decorating structure: in clay, color and substance are one and the same. Simonds's increasing interest in color can be traced from the earliest Dwellings to the most recent installations, developing from the basic red clay (which Simonds identifies as sensuous, malleable, plastic, connoting flesh, growth, and by extension, the body); and the gray (more quartz content, hence harder, mineral, "stone," and things built); to the broad spectrum which appeared in the later 1970s. In each instance he uses the colors of his clay symbolically to allude to the generic identities of the major sectors of his landscapes, such as yellow (neuter), pink (female), gray (male). In simpler works the color distinctions may be more basic—red clay (flesh, landscape), gray clay (stone, architecture); here the shape of the structures themselves helps to identify the gender.

Color is also used as a simple metaphor for the passage of time and the changes of state substances undergo as they age or grow. In *Circles and Towers Growing*, the most developed example, we witness the evolution of the 12 landscapes through a chromatic sequence in which the dominant colors in each work change from yellow to pink to red and red-orange to brown and pale gray. Here yellow denotes the wet flatlands from which pink landforms swell. Poured onto the work as a thick soup to fill "rivers" and "swamps," the yellow clay is also used as dried bricks in constructions of many colors which symbolize for Simonds a literal "mixing of ingredients" from the various regions into one unified culture. The number of colors, the complexity of design, and the levels of structural or stylistic sophistication achieved imply the relative success or failure of assimilation (see *Circles and Towers Growing, Commentaries, Number 5*). Thus for Simonds, color is an integral part of his conception for each sculpture, establishing a cast of characters with multiple roles; roles that derive both from traditional usage and Simonds's own intuitive mythologies; roles, moreover, which he feels free to modify—even reverse—should the colors begin to appear only as fixed and inevitable accompaniments of form.[8]

Although Simonds has discussed his work in terms of all the above, it would be misleading to read into these images a rigid code. On the contrary, the imagery and many of its subtle (and not so subtle) associations are generated not from formulas but very much from the materials immediately at hand—as when the first idea for making his landscapes came to him from a casual, suggestive working of some clay.[9] It is fair to say that Simonds thinks in clay the way other artists might think with pencils, unconsciously, instinctively. It was clay that most intrigued him as a child, and with exceptions (see pls. 28, 30), he has avoided making drawings, a process that he finds personally uncomfortable and something of an ordeal.[10] But with clay Simonds is at ease, literally in his element.

As a sculptor he appreciates clay's fundamental simplicity. This is in the sense of clay as material as well as for its unparalleled richness of associations (Adam: "born of red earth"; the most primitive art material, etc.).[11] Inexpensive and easy to store, capable of receiving the most sensitive pressures from the artist's hands, clay functions as form, color, texture all in one. Using only water, Elmer's Glue, and simple tools, Simonds transforms the clay in his

miniature landscapes into an instrument of illusion, creating brick, stone, and a veritable atlas of landforms. The degree of fantasy conveyed through these tiny environments is not unlike that which we traditionally associate with painting, a sense of fantasy that is extremely difficult to evoke convincingly in three dimensions.[12] Yet everything is clay and natural materials (even the slips used to decorate the Little People's abandoned pottery are mixed from colored earths): no artificial substances are used.

Simonds's personal identification with the earth (evident in his early rites such as *Birth*, pl. 1) extends to his pleasure in working it. This experience is frankly both sensuous and sensual and most profound when the clay is moist and wet, most intensely red or pink, its particular smells distinct. These are the moments when for him the clay is most responsive and alive. It is not surprising that he is more engaged with a kind of physical intensity while giving shape first to the landscape than during the obsessive placing of tiny bricks; that his emotional involvement with a work is in direct proportion to its immediate, physical presence, and that it diminishes as the clay dries, fades, hardens, and ceases in his mind to grow. Like a flower that loses its color after pollination, the finished sculpture for Simonds loses much of its attraction.[13] The landscapes, particularly those in series, can be reworked in response to one another; but the overwhelming feeling of Simonds working is one of absorption in the process of making—as though the activity as well as the clay lends the necessary unity to each work and links it to those that came before.

The mixing of earths gathered from different sites, each corresponding to present or previous projects, is thus both ritual and economy, the literal genealogy and unity of "The Work,"[14] one piece feeding directly or indirectly into the next, a genetic pool through which each landscape, each moment in the history of the Little People, finds its place. At the same time Simonds appreciates the simple pleasure of being able to recycle his sculptures with water, regenerating the clay and beginning all over again the ritual of chaos and order, construction and destruction, soft to hard, and wet to dry. Simonds's work thus operates on a principle of remarkable utility in form and content, each aspect reinforcing visually and intellectually what he conveys through the "emblematic" architecture[15] of his invisible medium, the Little People.

The sculpture, read with patience, reveals or evokes much of its meaning. There are, however, other levels of potential understanding less visibly apparent in the work itself that help us to perceive the underlying sense of unity which, to an unusual degree, prevails in nearly every aspect of Simonds's life and his activity as an artist. One can learn much and enhance the experience of viewing the sculpture, for instance, by taking advantage of the fact that Simonds is not afraid to use words. He seems confident that the work can stand on its own, so feels free to expand the potential accessibility of his work in statements, interviews, mythologies (see *Three Peoples* below), titles, and extended captions.[16] Simonds described his new cycle of *Circles and Towers Growing* in a French catalogue in 1979 as follows:

> This work comprises a series showing the evolution of a landscape and of an architecture in my imaginary universe. Each work depicts the same place at successive moments in time.

After the third landscape the rest divide into two series with different interpretations.

One employs towers, fire and rituals of sacrifice; the other uses the circle, water, and rites of reproduction, as well as observation of the stars.[17]

As in his other writings, Simonds here invokes the presence of civilizations seemingly very remote from ours, cultures whose customs we reconstruct from the archaeological evidence of their dwelling sites, specifically those values imbedded in their architecture. It is from the types of buildings, their detailed construction, apparent demise, and selective re-use that we are led to imagine the civic and religious priorities, the mind-set, the cosmology of these unseen builders whose very invisibility frees us to consider parallels with our own lives and futures.

The imaginary situations Simonds proposes in his landscapes can be seen as related to a variety of fantastic civilizations, contemporary and traditional, literary and real. The notion of a migrating race of tiny builders is not totally dissimilar to the actual discovery recently in the Philippines and Brazil of small, isolated groups of people living much as they did in the Stone Age. Or, to those experimental communities in the United States and elsewhere established in anticipation of how the rest of us will be living in the next century. One can also compare Simonds's fantasies to those of Jonathan Swift in *Gulliver's Travels*, Jules Verne's *The Floating Island*, the science fictions of his favored Stanislaw Lem, or the poetic reveries of Italo Calvino in *Cosmicomics* or *Invisible Cities*.[18] In each instance other places and other times are explored through the imagination as comparative models, often to suggest alternatives to current practice and ways of thinking. Fantasy and exaggeration—such as miniscule beings or the unexpected application of technology (as in Simonds's own *Floating Cities* concept) are not merely play. By stimulating our imaginations, the fantastic allows us to cut through the detailed complexities of the late 20th century, "to step outside the present and see it in an altered light."[19] The dramatic simplicity of the tabletop environments, where topography and architecture evolve as though in time-lapse photographs, clarifies the consequences of the fictive civilization's operating principles or myths. These histories, however, are invisible (like the Little People), without the freedom and perspective released by fantasy and reflective imagination.

Unlike the 19th-century American visionary painters with whom Simonds shares a certain sense of mission in alerting us to the consequences of our ways,[20] he does not moralize. One has to work for the message by a careful reading of the site—its overall schema as well as its details. Each area of the landscape (or "phrase" as Simonds refers to them) has its own story; and everything, as in myth and folklore, is alive and has potential meaning. Simonds makes frequent reference, for instance, to the venerable tradition of the Four Elements—earth, air, water, and fire—alluding to their literal physical properties, but more importantly, to their symbolic meanings and rich associations, as in alchemy. This may seem an archaism on the part of an artist whose futuristic *Floating Cities* is based on current technology and "economic inevitabilities," who works on community development projects, and who reads the business section first in *The New York Times*. But it is consistent with his openness to ideas that he considers useful, whatever their

source. As has been noted in another context, although the Four Elements "are not a conception of much use to modern chemistry . . . [they] are still the four elements of imaginative experience, and always will be."[21]

In *Circles and Towers Growing,* Simonds contrasts respectively the use of water and fire; but it is here a matter of predominance, not exclusivity. And again he requires us to exercise our imagination in order to see: we cannot literally peer down into the underground chamber beneath the central dome in Circles *Numbers 4, 5,* and 6 (pls. 35-37); but we can read in his account of the "People Who Live in a Circle" (below) the role of fire in the annual rites of rebirth. We can also find actual burnt things in many other Dwellings or ritual architecture pieces, implying the past presence of fire just as the prior mixture of water and earth is manifest in each brick. The landscape itself is a living chronicle of the "great cosmic marriage" between Sky Father and Earth Mother (as the Pueblo Indian cosmogony describes it), consummated through lifegiving rain.[22] Appropriately, Simonds mixes water with his various clays to replicate specific weathering effects: drying swamps, riverbeds, parched deserts. He also orders and domesticates water with constructed sluices (e.g., *Number 5,* pl. 36) appearing in place of natural run-offs, signifying a higher state of evolution and the necessity of controlling water resources for the development of permanent communal societies. Water is a primary index by which we follow the course of the *Circles and Towers* cycle. Yet water itself is never literally present in the finished sculptures. This is one of the reasons that Simonds's tabletop civilizations transcend the miniature effects of models and dioramas. As we know from Hollywood naval epics filmed on soundstage oceans, water—unlike earth—is nearly impossible to reduce convincingly in scale. Instead, as with so much else in these vivid little worlds that seem at first so overloaded with detail, we must again resort to imagination to infer water from the occasional pottery vessels, tree saplings, and (given the fact of permanent settlements) an agrarian culture.

Neither does Simonds show us tiny figures frozen in games or meditation, casting shadows. As in so many photographic "portraits" of contemporary buildings, there are no people present to distract. He tells us the buildings are abandoned, but for five minutes or five centuries, he does not say. We have only the heights of doors, the distance between rungs on ladders, and similar subtleties as clues to the Little People's stature and thus the prevailing scale. Like fire and water and the underlying meanings of these deceptively simple works, the Little People themselves are quite invisible without the magnifying powers of imagination. And it is for the sake of imagination that they are *not* there.

Everything depends upon our willingness to open up ourselves and mentally engage the vistas, bits and pieces, constructed by the artist. Imagination is simply the key to participation.[23] That is one reason why Simonds's architectural references are indirect, never precisely reconstructions of Hopi pueblos and kivas, pre-Columbian terraces, Egyptian mastabas, Greek tholos tombs, or Iron Age brochs. Rather, his buildings and sites are evocative of all of these and more, together with their unavoidable associations of mythic prehistory and archaeologic interpretation. He calls these references "impressionistic,"[24] yet the allusions are to histories we understand were real, to the rise and fall of civilizations. Simonds appeals to our sense of historical fact—the meticu-

lous details suggest that his vision is authentic—but he does not specify when and where. He insists upon, if not free, then unencumbered associations, studiously avoiding analogies with the Roman Empire, for one, whose infamous decline has been so often cited as to preclude the imaginary reconstructions his sculptures really demand. He leaves to others the weary clichés of catastrophe—the broken Corinthian columns, Ozymandian hulks, and Rivers of Blood.

But certain of his earlier structures, particularly those of the Linear, Circle, and Spiral Peoples (pls. 12-14) do attain something of the nature of archetypes themselves despite their small size. It is clear that these three buildings are direct communal and systematic expressions of belief, like medieval cathedrals.[25] In this important respect these tiny buildings can be compared to the great archetypal monuments such as the Pyramids, or particularly, the Tower of Babel (fig. 1), which is also a construct of oral and written histories, existing ruins, and above all the imagination.[26] Simonds compares Babel (perhaps the single structure most symbolic of human aspirations in architectural form) with the Spiral People who build until their edifice crumbles beneath them, a parallel others have drawn with contemporary urban life. He sees these structures as "emblematic," embodiments of both ideas and what he calls "certain biological aspects of life and the body's functions: Thus the labyrinth approximates a seduction, and the incinerator digestion, and the mastaba—death."[27]

In 1972 Simonds began a series of clay object sculptures which he called *Life Architectures/Living Structures,* an idea he expanded in *Three Peoples,* a short book of "fictional ethnography," whose text is reprinted below. From the early 1970s onward, however, Simonds has shifted the emphasis in his sources from anthropology and the social sciences to nature. What interests him most in these living models are their various kinds of social organization, specifically their methods of growth and adaptation.

Most recently this interest in simple life forms has been directed to flowers (pls. 44-46), but Simonds finds his inspiration in fauna as well. He has referred to his fascination with the economy and beauty of animal architecture, to the termite and the caddis fly.[28] Here he finds the original vernacular architecture, adaptive and economic dwellings that succeed without architects.[29] Within "the specialized cellular organizations of simple aquatic organisms (nervous, digestive, reproductive systems, etc.),"[30] he finds analogies to the economic and social configurations that he elaborates in his model of *Floating Cities/ Maritime Communities.* His reading and interests, his lifelong education in the Museum of Natural History in New York, and his explorations of models of life forms that "grow, evolve and change according to need,"[31] take Simonds far beyond traditional notions of sculpture or architecture or even definitions of what artists do.

But it is in this preoccupation—trying to find insights and alternatives to very pressing contemporary issues—that Simonds also finds the potential means to extend our definition of art.[32] Or, more accurately, to restore to art the definition which one can trace back to those primal sources evoked by his own miniature encampments and ritual places: to magic—in its basic definition an attempt to understand and control natural forces—a means to deal actively with existence. And, thereby, to restore to art a social function.

Certainly Simonds seeks to undergo in his shamanistic Mythologies the same kind of ritual death and rebirth that initiates experience in tribal ceremonies: being one with the earth, in harmony with the universe. (This is not simply a "performance" in the 1970s sense of the term.) But he is also a realist about the possibilities of art transforming the world. Thus he feels free to imagine, to reject nothing of potential use, whether from modern science or myth. Simonds functions comfortably and with a surprising sense of overall plan in this amalgam of the rational and the less rational, the systematic and sheer intuition. The model for *Floating Cities* is the result of one such hybrid, a concept connecting today's seagoing factories to the mythologies of Atlantis or the *Odyssey* in a model for a sea-based economic community structured upon patterns of blue-green algae, one of the most primitive and simple forms of life.[33]

One can readily see that in Simonds's universe there is considerable flexibility. Priorities are the acceptance of all possibilities for mutual adaptation between an organism and its environment, the two-way communication he himself encourages in his neighborhood street pieces.[34] For Simonds, learning is a means to survival. There can be no advantage in rigid formulas, simplistic and deterministic definitions of either/or. As he has stated: "I've always thought of my work as transsocial, transpolitical, transsexual and transparent(al)."[35]

Consequently, while one can read Simonds's sculptural forms as male or female, it is more accurate to see them often as somewhere in between, sharing characteristics of both sexes, more one than the other according to circumstances. The *Growth House* (see pl. 28), for instance, Simonds calls hermaphroditic because it combines construction (a male principle here) with growth (a female principle): the earth bricks are laced with seeds. In fact, it seems that Simonds actually uses two related concepts and terms interchangeably, androgyne and hermaphrodite. Both are fundamental to our understanding of the various levels on which each of his works can be interpreted.

Today, for example, we tend to associate androgyny with asexuality, rather than its original sense of both sexes in one, a universal symbol of unity and wholeness.[36] Likewise with the hermaphrodite, we fix on its literal aspects— the presence of both male and female sexual characteristics in one organism —and forget entirely its significance as a symbol. Both androgyne and hermaphrodite have been used traditionally to represent other pairs of opposites, dualities such as sun/moon (male and female respectively), fire/water, heaven/earth, odd/even numbers, right/left, up/down, light/dark, ad infinitum. This quest to unify or harmonize opposites within oneself, to attain a oneness of mind and body, is a familiar theme to students of comparative religion or psychology; so, too, are the related subjects of sexuality and fertility.[37] Working with these archetypal images and ideas, Simonds mixes them in his erotic landscapes to create highly charged and recognizable symbols for the evolution of his imaginary civilizations. Landforms and architecture alike take on the physical forms of a human sexuality, thus simplifying comparison of the changes which occur from one sculpture to the next. Despite daily confrontation with sexual stereotyping, it is initially surprising to see these symbols used here so directly with their original meaning undisguised.

If the primary images in Simonds's works are sexual, however, their full meaning is in terms of basic function: to engender the capacity for growth and change and therefore to mark the passage of time.[38] And time—as something fluid, amorphous, without specific geologic or historic reference—is central to an understanding of what the art means. To establish the cultural relativity of time, Simonds invented the distinct temporal modes in *Three Peoples,* together with their appropriate architectures; that of the *People Who Live in a Circle* (pl. 14) even functions "as a personal and cosmological clock, seasonal, harmonic, obsessive." To represent multiple, even simultaneous moments in sculptural terms, he also devised two basic types of narrative, one which he calls the "picaresque," the other typified by *Circles and Towers Growing.*[39] In addition, his films, photographic montages, books, and other sculptural works also impart (and assume) their own pace and rhythm. His intricate sculptures express within themselves the time it required to make them. Yet it is their identification within a particular context, whether vacant lot or museum, which determines their duration or fate.

Simonds moves freely through time within his works. The archaeological references are more than a nostalgic invocation of simpler epochs or an escape from contemporary issues, however. The vistas into past and future all ultimately focus in the present. Everything in his work is predicated upon our reading of it in the present tense, upon that critical activity we consciously undertake in the here and now.[40]

If we tend to see the past as something that slowly grew, or the present as a blur or interminable, it may be more often the case that we are so busy living that we do not think about time at all. Simonds gently and provocatively pries us out of our habits to experience briefly the possibilities of existence through new eyes, minds, and times. In the process, he reveals the growth which we perceive as changes of form and color and style—of relationships —between a landscape becoming architecture. He makes no distinctions between them in their recurrent cycles of life and death, and so suggests thereby the underlying unity of all things. The idea is very simple. And the sculptures are, for their timeliness, no less magical as art.

Footnotes

References to sources included in Bibliography are indicated as Bib. followed by section, year, and author or location of exhibition.

1
See Bib. I 1975, Simonds and Abadie, pp. 10-11. Translations are by the author unless otherwise noted. Bib. II 1977, Buffalo printed a revised version of the original statement in English which had been translated into French for *Art/Cahier 2.* An edited version was excerpted and combined with Bib. I 1974, Simonds and Lippard, also updated, in Bib. I 1978, Simonds and Molderings, in German and English.

2
Charles Simonds, statement in Bib. II 1980, Daval, p. 121.

3
Bib. I 1975, Simonds and Abadie, p. 11.

4

"I think of the dwellings in a very narrative way. It's the story of a group of people moving through life and the possibility of their survival as a fantasy in the city. The meaning comes only through seeing more than one in relation to another. There is also a sequence of events within each dwelling, each scene; the pathos of something coming to be and being destroyed, living and dying. . . . When I first appear they are beginning to build, and by the time I leave they've lived a whole life cycle . . ." (Bib. I 1974, Simonds and Lippard, p. 38).

5

George Kubler, *The Shape of Time*, New Haven: Yale University Press, 1962, pp. 33-34.

6

In conversation with the author, June 13, 1981. Unless specifically noted, quotations from the artist in conversation are from notes made from September 1979-September 1981.

7

Should the *Picaresque Landscape* ever be acquired, *Circles and Towers Growing* would theoretically require a replacement. This could be a different kind of work and still keep the overall sense of the cycle intact.

8

Simonds's normal use of red and gray is inverted, for example, in *Ritual Garden* (pl. 19). Associations are tied to certain places, certain forms, so that different materials or colors allow him to renew the forms, changing "what it means and how it gets to you" (conversation with the author, June 13, 1981).

9

". . . he began playing around with wet red clay, building up shapes that evoked images of various body parts and fantasies about bodily functions. One afternoon, he sprinkled white sand on top of a slab of wet clay and was struck by the 'geographical' effect. 'The sense of a particular place came to me,' he told us. 'Not an object but a place— something you could fall into . . .' " (Bib. II 1976, Jonas, p. 39). See Bib. I 1975, Simonds and Abadie, p. 5 for Simonds's account of his work of the late '60s, particularly the transformation of his apartment into "fantasy places," and Bib. I 1978, Simonds and Molderings, p. 16. Simonds sees almost everything he has done over the last decade as "an extrapolation of three or four simple thoughts, all of which I had in a few days" (Bib. I 1975, Simonds and Abadie, p. 13 and in translation [see note 1]).

10

See the large pen and ink drawings from 1975 for the *Linear People* (Bib. I 1975, Simonds and Abadie, p. 50) and *Growth House*, and *Growth Brick*, ibid., pp. 68-69. A sketch for *Birthscape* (pl. 23) is reproduced in Bib. II 1978, Amsterdam, beneath Simonds's statement (n.p.).

11

Simonds recalled the influence of "an older brother who worked realistically in clay at home—and my own interest in clay as the most traditional art material, and as a *prima materia* of life" (Bib. I 1975, Simonds and Abadie, p. 5, and the translations). The origins of Adam in the red earth is discussed in Thomas B. Hess, *Barnett Newman*, New York: The Museum of Modern Art, 1971, pp. 56, 85. See also the discussion of "Red Adam" in "Jorge Luis Borges," *Writers at Work, The Paris Review Interviews*, 4th Series, New York: Penguin Books, 1977, p. 119. Simonds also appreciates the irony that his tiny bricks are made from the same New Jersey clay that provided the building materials for many of the older buildings in New York.

12

See Lucy R. Lippard, "Max Ernst and a Sculpture of Fantasy," *Art International* 11, 2 (February 20, 1967), p. 27.

13

Conversations and Bib. I 1974, Simonds and Lippard, p. 38: "For myself I think in terms of making. Their high point for me is the moment when I finish them, when the clay is still wet and I'm in control of all the textures of the sand and the colors, when earth is sprinkled on the clay and it's soft and velvety, very rich. As they dry, they fade and cease to be as vivid for me." Also see Alec Bristow, *The Sex Life of Plants*, New York: Holt, Rinehart and Winston, 1978, p. 200. Simonds is interested in the various kinds of reproductive behavior in plants and animals and has books on the subject, including this one. One can find numerous passages in Bristow that evoke Simonds's sculptures, cf. the signs of female arousal, p. 26, and the landscape in " \triangle " *Early*, 1977, Coll. Walker Art Center, ill. in Bib. II 1977, Minneapolis, p. 62.

14

"The Work" refers to *The Great Work* of the alchemists, the quest for the *Materia Prima*. Alchemy is of some interest to Simonds, though not in the misunderstood sense of a naïve attempt to transmute lead into gold. Alchemy was as much a spiritual discipline as a material procedure, the goal of which, in very simplified terms, was "to know the centre of all things" (Stanislas Klossowski de Rola, *Alchemy, the Secret Art*, New York: Avon, 1973, p. 8). Simonds's interest in the subject can be traced in part to C. G. Jung's epic study, *Psychology and Alchemy* of 1944, translated 1953, Princeton: Bollingen Series. For Jung, alchemy was of interest as a parallel to early Christianity, specifically as a compensation for "gaps left open by the Christian tension of opposites" (p. 23). As a means to attain wholeness of being, alchemy is analogous to efforts of modern psychology to reconcile the inner and outer man. The images are a virtual encyclopedia of medieval lore, including the Four Elements and the Hermaphrodite discussed in the essay. Given the intimate conceptual and physical relations between the entire range of Simonds's art works and his other activities, the idea of "The Work" —the ongoing quest—seems appropriate; Simonds agreed. Simonds was also interested in the idea that the cells in all organisms have both male and female chromosomes, "a physical image of man's psychic 'bisexuality' " (discussed in C. G. Jung, *Man and His Symbols*, Garden City: Doubleday/Windfall, 1964, pp. 30-31).

15

Bib. I 1975, Simonds and Abadie, pp. 12-13. Simonds uses the term "emblematic" to describe the relation between his "unique" works, the portable sculptures, and the temporary Dwellings. "The objects are more extravagant to the extent that I devote a great deal of time to one thought. The objects attempt to bring the same thoughts that underlie the street works to the state of an emblem. . . ."

16

See Bib. I. Other particularly useful published statements by the artist are cited in this essay and the *Commentaries*, notably Bib. II: 1978, Amsterdam; 1980, Foote; 1980, Daval. Simonds frequently uses the occasion of catalogues and articles to revise or expand earlier statements, titles, etc.

17

Bib. II 1979, Les Sables-d'Olonne, "Evolution imaginaire d'un paysage" (n.p.).

18

Simonds has copies of Swift and Calvino, the latter suggesting many parallels for Simonds's writings as well as sculpture. One can cite "Olinda," the "city that grows in concentric circles," or "Clarice," which gave up nothing but "merely arranged [it] in a different order . . ."; or "Beersheba," two cities, one "suspended in the heavens," and another, fecal city below (*Invisible Cities*, trans. William Weaver, New York: Harcourt Brace Jovanovich, 1978). The last city could be compared to the nests of termites which interest Simonds because of the integration of bodily functions and structure. See also Wolfgang Pehnt, *Expressionist Architecture*, London: Thames and Hudson, 1973, esp. p. 163, for a discussion of early-20th-century architectural fantasies, including Finsterlin's "grown" house and Steiner's "Goetheanum."

19

Bib. I 1978, Simonds and Molderings, p. 23.

20

Compare the themes and narrative devices used in paintings and painting cycles by Thomas Cole, "The Course of Empire," *Past* and *Present,* among others. See Abraham A. Davidson, *The Eccentrics and Other American Visionary Painters*, New York: E. P. Dutton, 1978, pp. 17 ff. and p. 13 for a discussion of the popularity of cataclysmic themes in the 19th century.

21

Northrop Frye, preface to Gaston Bachelard, *The Psychoanalysis of Fire,* trans. Alan G. M. Ross, Boston: Beacon Press, 1968, p. vii. Among Bachelard's other books which stress the value of the "active imagination" is the influential *The Poetics of Space,* which explores the phenomenology of such spaces as the House, Nests, Shells, Corners, Miniatures, and "The Dialectics of Inside and Outside." The reading of this book and Bachelard's *The Poetics of Reverie* are for the author a literary experience comparable to the viewing of Simonds's sculptures. Bachelard's references to Jung take such ideas as the duality in the psyche of animus (masculine, dream, concepts, activity) and anima (feminine, reverie, and repose) and develop them in terms that resonate with Simonds's world.

22

Cottie Burland, *North American Indian Mythology,* London: Hamlyn, 1975, pp. 120 ff., "The Creation of the World." Simonds has said that the Little People's origin "lies somewhere among my childhood visits to the Southwest" (Bib. II 1977, Buffalo, p. 7) and has referred elsewhere to the image of the Dwellings as "of a moment past, a part of America's past, like the Pueblo Indians . . . (Ibid., p. 10). He also related his Dwellings to "the American Indian," because the Little People's lives also "center around belief attitudes toward nature, toward the land . . ." (Bib. I 1974, Simonds and Lippard, p. 38). Simonds knows the Indian sites of the Four Corners area well and returns for certain rare dance ceremonies. The architectural similarities between Simonds's Dwellings and circular structures and Hopi buildings are clear but account for only some of his many architectures. The dry locale of Simonds's tableaux also relates to the arid cliff regions of the Pueblo. One can also compare the Hopi cosmogony with its account of the four-fold womb ("The Place of Generation, the Place beneath the Navel, the Vagina of Earth, and the Womb of Birth") from which the Hopi gradually made their way to the surface world and undertook a migration in the form of a spiral. See particularly *Circles and Towers Growing.*

23

Bachelard (see note 21) places the powers of the imagination between those of thought and reverie. "And it is here that the intermediary play between thought and reverie, between the psychic functions of the real and the unreal multiplies and crisscrosses to produce the psychological marvels of human imagination. Man is an imaginary being" *(The Poetics of Reverie: Childhood, Language and the Cosmos,* trans. Daniel Russell, Boston: Beacon Press, 1971, p. 81).

24

In conversation with the author.

25

Kubler's category of "Prime Objects"—indivisible, inexplicable by their antecedents, etc. *(The Shape of Time,* p. 39) is applicable to a theory of archetypal buildings. He notes that "the number of surviving prime objects is astonishingly small: it is now gathered in the museums of the world and . . . it includes a large proportion of celebrated buildings" (p. 41).

26
The Tower of Babel is referred to in the Bible (Genesis 11:1-9) simply as "a tower with its top in the heavens." Herodotus refers to a great temple in the center of Babylon with "a solid central tower, one furlong square, with a second erected on top of it and then a third, and so on up to eight. All eight towers can be climbed by a spiral way running around the outside . . ." (*The Histories*, trans. Aubrey de Sélincourt, Baltimore: Penguin Classics, 1961, p. 86). Pieter Bruegel the Elder painted two versions of a *Tower of Babel* in 1563, basing his image on the written sources above and his visit to the remains of the Colosseum in Rome as well as contemporary machines. See H. Arthur Klein, "Pieter Bruegel the Elder as a Guide to 16th Century Technology," *Scientific American* 238, 3 (March 1978), p. 134. In both the "large" and "small" Babels (Vienna and Rotterdam), Bruegel uses color changes to distinguish newer from older construction.

27
Bib. I 1975, Simonds and Abadie, p. 13.

28
". . . I investigate the parallels between the unconscious behavioral patterns (my own, those of humans and animals) and social and environmental forces, as a means of provocation and social change. Through new art and architectural possibilities I am particularly interested in the evolution and psychological implications of sexual interactions between body and earth, house and body and home, building and growing—from the behavior of termites to human social systems . . ." (Bib. II 1980, Daval, p. 121). (See also note 18 above.) ". . . and I've learned more from watching the small-brained genius of the caddis fly larva building its house . . . than by studying the work of large-brained architects" (Bib. II 1980, Foote, p. 29). Simonds admires greatly the beauty and economy of animal structures, from microscopic animals through shells, arthropods, and the vertebrates. He has a copy of the classic study by Karl von Frisch, *Animal Architecture*, trans. Lisbeth Gombrich, New York: Harcourt Brace Jovanovich, 1974. The first chapter is entitled "The Living Body as Architect—."

29
Simonds's interest in how building reflects living is evident in his work in transitional neighborhoods and his notes about buildings he sees in his travels. With many artists he is interested in the "vernacular, anonymous, spontaneous, indigenous, rural" structures assembled in Bernard Rudofsky's book *Architecture Without Architects*, New York: Doubleday, 1964, which accompanied an exhibition of the same title at the Museum of Modern Art, New York in 1965. See also Rudofsky's *The Prodigious Builders*, New York: Harcourt Brace Jovanovich, 1977. An article which expresses an attitude very similar to Simonds's is Richard Bender's study of mud architecture in Morocco, "Dust to Dust—The Ultimate System," *Progressive Architecture* 54, 12 (December 1973), pp. 64-67.

30
Bib. II 1980, Daval, p. 121.

31
Ibid.

32
See Bib. II 1979, Linker, for an extremely thoughtful and provocative discussion of Simonds's art, esp. p. 37, where she concludes: "Instead of extending art into nonart contexts, they [his land projects] propose broader, more flexible definitions of art. And this reorientation of esthetic objectives is perhaps the most important thing that these objects, like Simonds's Dwellings and models, are about." See also her footnote 17 for a proposed analogy between the models for *Three Peoples* and art theories.

33
Bristow, *The Sex Life of Plants*, p. 69, proposes that blue-green algae, pre-dating sex, and therefore death, "can be said to be immortal." He then describes blue-green algae living in the oceans today as "not merely descendants but actual parts of that same (original) organism and so could be described as at least two billion years old." Simonds, understandably, has annotated this passage with an exclamation point.

34
"Certain kinds of machines and some living organisms—particularly the higher living organisms—can . . . modify their patterns of behavior on the basis of past experience so as to achieve specific antientropic ends. . . . The environment, considered as the past experience of the individual, can modify the pattern of behavior into one which . . . will deal more effectively with the future environment . . . seeks a new equilibrium with the universe . . ." (Norbert Wiener, *The Human Use of Human Beings: Cybernetics and Society*, Garden City: Doubleday Anchor, 1954, p. 46). Simonds has read this and other Wiener books, stressing his interest in their discussion of two-way communications and theories of learning.

35
Bib. II 1960, Foote, p. 29.

36
See Jung, *Psychology and Alchemy*, pp. 161-162 etc.; and June Singer, *Androgyny*, Garden City: Anchor Books, 1976, esp. Chs. 9, 12.

37
See Jung, *Psychology and Alchemy*; and Mircea Eliade, *Patterns in Comparative Religion*, trans. Rosemary Sheed, New York: Meridian Books, 1971, pp. 223, 262, 421, 424, etc.

38
"Time, like mind, is not knowable as such. We know time only indirectly by what happens in it: by observing change and permanence; by marking the succession of events among stage settings; and by noting the contrast of varying rates of change" (Kubler, *The Shape of Time*, p. 13). This could serve as a description of Simonds's work as a whole, particularly *Circles and Towers Growing*.

39
". . . More recently I have been working on a series of projects that trace the interior evolution of landforms into architectural forms in this imaginary civilization. The methodology of these works involves either the bringing together of many different imaginary times and places to one real time and place (picaresque) or the investigation of one particular place at many different times. These works are counterweights to the street Dwellings where time and place follow each other in quick succession with the past constantly slipping away into nothingness and death" (Bib. II 1978, Amsterdam, n.p.). In conversation Simonds explained his use of "picaresque," a literary term designating a style of fiction which follows the adventures of a roguish hero. Simonds likens large installations such as *Picaresque Landscape*, " △," and *Birthscape* (cover ill. and pls. 21 and 23) to picaresque novels because they are (1) objects, like books, which (2) bring together in themselves—in one place—a variety of different events.

40
"The streets are really where my work finds its meaning and direction, in people's reactions to it. . . . It awakens and politicizes that consciousness" (Bib. I 1978, Simonds and Molderings, p. 23). One can also see in the domed stadiums and office towers around which our cities seek to rebuild themselves parallels to Simonds's *Circles and Towers Growing*, the focal points for energy and resources.

On the Loose with the Little People:
A Geography of Simonds's Art

By John Beardsley

Much recent art has demonstrated a renewed preoccupation with landscape. Land art, sited sculpture, and certain kinds of performance have added to the traditional forms of landscape depiction in painting and photography a new level of involvement with the earth, its contours and materials. But even those new works most sensitive to their particular physical situations retain with the earth something of the conventional figure-ground relationship that characterizes images drawn on canvas or paper. While Robert Smithson's *Spiral Jetty* was generated by the topographic, geological, historic, and even mythological features of its landscape,[1] it is nevertheless quite apparently a mark on the ground. It reads as a drawing as much as a landscape element.

Charles Simonds shares in the current preoccupation with landscape, yet in a way that begins to subvert the traditional figure-ground relationship. His work hypothesizes an identity between the landscape, the structures we build on it, and our bodies. Peripatetic, Simonds wanders the urban and natural landscapes of the world, musing, recording, testing his hypothesis. He observes the varying modes of our lives in different landscapes and the ways in which our social conventions, our architecture, and the evolution of our thought correspond to where we live. His works are the physical expression of these observations. In fantasy form, they tell us of the "Little People," of their migrations and their haltings, of their rituals and their beliefs. As the Little People move through a landscape, their beliefs and the forms of their architecture evolve, in part as a response to their physical surroundings. But these miniature landscapes and dwellings also reflect upon us. In encouraging us to contemplate the social and architectural structures of the Little People, Simonds makes us aware by comparison of the structures of our own lives.

This comparison was perhaps most forcefully drawn in a piece that Simonds executed on a rooftop at P.S. 1 in Queens in 1975 (pl. 5). Spread out behind the

Figure 2. Charles Simonds working in Guilin, 1980.

miniature landscape and dwellings was the skyline of Manhattan. One could not avoid comparing the different architectures and the way they related to their respective landscapes. Implicit in the physical comparison was a contrast in the social and economic structures that had generated the architectures. The dwellings of the Little People held to the landscape, while the buildings of Manhattan seemed by comparison emphatic impositions on it, in opposition to the essential horizontality of the earth. At P.S. 1 as elsewhere, the forms employed by Simonds to represent the Little People are technologically naïve, while those of our society are not. The buildings of the Little People suggest in their casual disposition accretive growth, while ours conform to a logical, predetermined pattern. The comparisons are more numerous and the implications more elaborate, but they can be distilled into the assertion that the architecture of the Little People represents a culture that is more responsive to the physical environment than ours. Functioning thus as indicia of how people live, Simonds's works seem more the musings of a cultural geographer than the gestures of a conventional image-maker. The sense of gratuitousness that might at first be felt before the work is dispelled by a more lasting recognition that these pieces are most consciously rendered, and are meditations on the relationship between the physical characteristics of landscape, the body, and architecture on the one hand, and the intangible elements of culture on the other.

The identity between landscape, body, and dwelling was first postulated by Simonds in a series of films made in the early 1970s. *Birth* (see pl. 1), in which Simonds emerges naked from the clay, reveals a belief in the earth as the source of all life. In *Body —— Earth* (see pl. 2), Simonds uses the movements of his body to create contours in the ground, suggesting the relationship between earth forms and body forms. And in *Landscape —— Body —— Dwelling* (see pl. 3), Simonds lies naked on the earth, covers himself with clay and sand, and transforms himself into a landscape on which he builds a group of dwellings that conform to the contours of the body-earth. There is a kind of pathos to these films, as Simonds endeavors to merge his body with the landscape and subsume his male sexuality to the more androgynous character of the earth. Though his union with the earth is thwarted, the attempted conjunction of the body, the landscape, and architecture represented by the private ritual of *Landscape —— Body —— Dwelling* endures as one of the essential starting points of Simonds's art.

Simonds has incorporated this identity not only into the content of his art, but into the process of his art-making as well. If how we live (as symbolized by the Little People) is an expression of where we find ourselves, then how Simonds's art looks and what it means is conditioned by where it is made. This has given rise to a divergence in the forms of his work as they relate to the miniature civilization. The Little People first appeared in temporary landscapes and dwellings on the streets of New York's Lower East Side; they subsequently found their way around America and throughout the world with Simonds, to Paris, Genoa, Berlin, London and, more recently, Guilin (fig. 2) and Shanghai. At the same time, the Little People have been the subject of temporary works that Simonds has executed for special exhibitions, such as Documenta in Kassel or the Projects gallery of the Museum of Modern Art, New York. They have also been the focus of permanent pieces for museum and private collections. To those observers who would make Simonds the

sole surviving standard bearer for the radical politics of the late 1960s, the divergence between outdoor and indoor works, temporary and permanent, destructible and collectible, represents an irreconcilable moral and philosophical dichotomy. The former are simplistically identified as populist, the latter elitist. The outdoor works are thought to imply a refutation of art world structures and the commodity status of art, ideas of considerable currency in the 1960s. By comparison, the indoor, permanent pieces are seen as panderings to privileged taste. Yet because the audience in each of the situations differs, so does the visible expression of Simonds's art. The various forms can be perceived as efforts to engage a host of different audiences—either personally, as on the street, or indirectly, as in the gallery or museum—in a manner appropriate to the situation.

Simonds embraces some of the attitudes that emerged in the 1960s, particularly the desire to expand the audience for art. As he has explained:

> I do feel a commitment to making ideas available to as many people as possible, including art people, even if only as films, photographs and other "reflections". . . . But I am far more interested in taking what knowledge and understanding I've gathered from art out into other contexts than I am in dragging a part of the real world into the art world. . . . The change must lie in a change of audience—not bringing new goods to the same old people.[2]

Simonds's motivation is not exclusively ideological, however. He is sustained by the personal contact with his audience that is attained through his activities in the street. As he works, people gather to watch, prodding him for information about what he is doing and why. These encounters have provided Simonds with an anthology of anecdotes, ranging from one about an irate Berliner who demanded to know who had given him permission to smear clay on a public building, to the story of a youth in Guilin who, though unable to communicate with Simonds through any shared language, stood sentinel by him throughout, explaining his activities to passersby.

For the casual, uninformed observer who comes upon Simonds at work or, still more mysteriously, the traces of his efforts, the fantasy of the Little People must provoke a far greater sense of surprise, dislocation, and pleasure than that experienced by the museum-goer with prior knowledge of Simonds's production. One has the sense that it is provoking this surprise, together with the element of personal contact, that are Simonds's principal incentives for working outdoors, not the notion that he might be subverting institutional structures or the commodity status of art. He is simply pursuing his impulse to work, in the situation that affords him the greatest joy and the most satisfying interaction with his audience.

Simonds's openness to this contact, together with a commitment to improving the urban environment, has led to his involvement with groups such as the Lower East Side Coalition for Human Housing in New York on a variety of community development projects. Between 1973 and 1975, Simonds was instrumental in the planning and realization of a combined park and playlot between Avenues B and C in Manhattan (pl. 25). Invited by an arts organization to Cleveland in 1977, Simonds chose to work with the residents of the Erie Square housing project on the transformation of a vacant lot near their

buildings into a community park and garden. Simonds met with the tenants and coordinated their ideas for the space. "Everyone wanted to help," Simonds recalled recently. "The only ingredient I brought to the project was the growth brick." He enlisted the aid of neighborhood children to fill burlap bags with earth and seeds, and then encouraged them to use the bricks as building elements. While their parents planted gardens and dug a barbeque pit, the children built cones and forts with the growth bricks. Within weeks, their constructions had come alive with flowers and vegetables. "It was a wonderful project," Simonds concluded. "The tenants organized a great barbeque just before I left."

The landscapes and dwellings that Simonds creates outdoors reflect the conditions of their making. They must be executed quickly, often in a day or two. As a consequence, they must be small in scale and relatively uncomplicated in form. Being impermanent, they often function as quick studies of ideas that Simonds is developing. With the indoor works comes the fuller, more elaborate, and generally larger-scale elaboration of these ideas. *Picaresque Landscape* (cover ill.), executed for the Museum of Modern Art in 1976, measures 16 x 19 feet and includes a large, walled village in a mountainous landscape and the ruins of linear, circular, and spiral dwellings. It was formed in sections over a period of several months with the components worked together *in situ*. The piece created for Documenta in 1977 (pl. 21) was composed of ruined villages and triangular dwellings in a contorted landscape of red, gray, white, and yellow clay. And the pieces that make up the present exhibition, the *Circles and Towers Growing* (pls. 32-43), are in a sense the culmination of years of speculation about the Little People. These works are the expression of a vocabulary of forms that has been over a decade in the making.

But the *Circles and Towers Growing* have a purpose other than a purely formal one. They are emblems of the pieces that Simonds executes on the street, and serve to inform the art audience of the concerns addressed by the outdoor works. In a current project for the Whitney Museum in New York, Simonds will place a group of dwellings on a window ledge inside the museum, another on the outside of a building across the street, and a third farther down the block. Here, the deliberate juxtaposition of indoors and out, private and public, forces the art audience to acknowledge that these works have an extra-esthetic function: to draw us into contemplation of the physical environment and how we live in it. At the same time, Simond's willingness to work in the museum is an admission that it is the art world's recognition of his stature as an artist that not only keeps him fed, but also provides him with the opportunities to participate in community improvement projects such as the one at Erie Square in Cleveland. The art community also provides him with useful critical responses:

> I've never labored under the delusion that the art world could offer
> me the quality of emotional or ideological experience that I get from
> the anonymous person in the street. (But) there are aspects of my
> work that are more accessible to an art, architecture and anthro-
> pologically-educated audience and are thus more clearly reflected
> back to me through a situation such as a museum.[3]

Simonds's manifest preference for the direct contact with the public afforded by working in the street does not, then, preclude an interest in engaging the art audience. Indeed, his involvement with the latter goes beyond museum works. Almost since the initial appearance of the Little People, Simonds has been making pieces for private collections. Many of these are executed on the spot, the first under a piano in a New York apartment in 1971, and one of the most recent in the stairwell of a house in Belgium. Simonds is motivated to make these pieces in some cases out of affection for the recipients, in others because of an interest in the possibilities of the particular physical situation. The Belgian family gave Simonds the liberty of removing part of a wall beside the stairs, permanently altering the interior of their home.

If, finally, the dichotomy in Simonds's work between public and private, outdoor and indoor, destructible and collectible pieces seems irreconcilable, so much the better. It is refreshing to encounter an artist who embraces ambiguity, who, in aspiring to a wider audience, is not at all anxious about appearing inconsistent. The many forms assumed by Simonds's art and the many situations in which it is made, represent his best efforts to address the broadest possible public in the situations and the vocabulary most appropriate to them. Yet within the work there is a unifying logic that withstands these variations in form and audience. It is a logic based on Simonds's beliefs in the identity between the landscape, the body, and architecture, and in the relationships between where we are and how we live. These convictions help reconcile the works with their settings, reducing the figure-ground duality, and bring Simonds into closer contact with his audience. Compelled by his instincts as a cultural geographer, Simonds applies these ideas to every situation in which he finds himself. The result is an art of ostensible whimsy and ultimate gravity.

Footnotes

1
For the artist's description of the genesis of this work, see "The Spiral Jetty," in *The Writings of Robert Smithson*, Nancy Holt, ed., New York: New York University Press, 1979, pp. 109-116.

2
Quoted in Bib. I 1978, Simonds and Molderings, p. 20.

3
Ibid., p. 21.

Simonds: Life Built to Dream Dimensions[1]

By Daniel Abadie

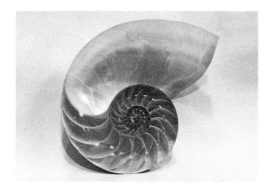

Some animals secrete their shells, man invents dwellings. The same imperious necessity commands them: to give form to space, to reduce the world to a known object, a possessed object. Because it situates the individual within an environment perceived first as hostile, the architecture of men retraces their vision of the universe: Gothic verticality has heaven as its end, classical space unfolds as the measure of the individual who strives to conquer the world and its powers. Cosmologies inscribed at once on the surface of the earth and in our memories, man's constructions are the lasting record of his passing—his way both of living and of vanquishing death. The first works of Charles Simonds participate in this dual nature; here are the raw qualities of instinctive behavior and the disillusionment of knowledge.

It is from his own body and his own space that the work of Charles Simonds has developed. First in his apartment where, in a series of successive moltings occupying one room after another even to the eventual expulsion of their creator, there accumulated objects and elements of all kinds, made from hair and from mucus, from clay and from dreams. The architecture also took part in the form of columns, stairways, fragments of a fetishistic stage setting for the body. How, raised in a family of psychoanalysts, could Simonds ignore this enactment of a return to the world of infancy? This re-creation—clay, the most malleable of materials which, under simple pressure from the fingers, take form—gave him a dimension at the same time physical and inwardly cultural. To the sensuality of modeling, to its demiurgic quality, is here especially added the primary erotic image of the earth mother, here buried in the most absolute oblivion. Referring to Robinson Crusoe:

> She represents a return to the lost innocence that each man secretly mourns. She reunites miraculously the peace of soft womb shadows and the peace of the tomb, one within and the other beyond life.[2]

Figure 3. Chambered Nautilus shell, cross-section.

This return to the beginning, this participation in the vital principle, Simonds made the subject of his first film, *Birth*. From the uniformity of the clayey earth he slowly emerges, nude and still covered with the original slime, as at the moment of the creation of the world. Beginning with this symbolic rebirth, culture and experience coincide in a totally ritualized universe.

It was in order to obey the implicit dictates of the clay that Simonds's first constructions were of ritual places. He strove to transfer his intimate knowledge of the material to them; to make himself, in miniaturizing them, both their creator and witness. This remote possession is in fact identical to that obtained by the witch doctor from his doll: it tends to confer upon one who at first is a submissive participant, the powers of a high priest. Thus it is not without reason that Simonds has naturally reproduced the successive periods of Genesis: life created from dust, the peopling of a formerly deserted world —and this to the very point of creating a miniature cosmogony. Man forms the link between the infinitely great and the infinitely small, between the universe that surpasses him and that he masters.

In more general terms, the art of the 1970s favored this turning to the miniscule, to the invisible, as if, after the spectacular demonstrations of color-field painting and Pop Art, it was appropriate to abandon retinal evidence in favor of mental acuity, surface for gravity. The defiance of art and its values, a constant for most 20th-century creators, is no longer foreign to this *reduction* that offers the lowest profile and partially avoids for its creator the label of artist. The films, the photographic works, the ephemeral nature of the Dwellings, the realizations in the street, spring from the same ethic—what Simonds is dealing with is less the nature of art than its social role. Moreover, this latter concern may seem in the early work to be the essential point of his quest. Simonds was not satisfied with working randomly in the streets. Quickly he concentrated his work in a section of the Lower East Side of Manhattan, bit by bit integrating himself with this community, responding to an unformulated expectation, playing the part of a catalyst rather than an artist. Thus, in the development of the Placita playlot (pl. 25), his contribution is scarcely visually recognizable: it is to be found in the very existence of the project and in the energy necessary to bring it to its conclusion. One might think that his work in the streets, parallel to the development of the sculptures, is in some way alien to them. Yet they are one, for the street works enabled the sculptures to take a new dimension, a mythological amplitude.

Simonds has stressed how from the moment his work was carried into the street the heroic achievement of the Little People was born:

> At this period (1970) there were, in fact, two different peoples who were at war: the inhabitants of the cliffs, hunters, who lived in the walls and projections of the buildings, and the shepherds who lived on the plain of the streets, in the gutters and against the foundations of the buildings. The cliff dwellers regularly came down to raid the plains dwellers. Finally conquests and assimilation united the two peoples.[3]

The street served as an echo chamber to the summary buildings which at that time Simonds strewed among the jagged outlines of the city walls. There were the comments of the passersby, the neighborhood children, who helped formulate the true mythology of the Little People. The spectators formulated, in a collective projection, the chronicle of this people, explained their cus-

toms, justified their constructions. The freedom of the creator exists in the limits permitted him by this general acceptance. This double relation of the artist to the Dwellings and the Dwellings to the public progressively determined the major characteristics of the Little People's architecture and, initially, its tie to the sacred. Detached from all utilitarianism, the image of the city recovers its original dimension; an image that represents at the same time geomancy, translation of social structures, and delineation of religious and political positions. The differences thusly expressed are no longer based on culture but on behavior.

Thus Simonds was led to distinguish in a series of sculptures and a parallel text, three fundamental categories: people who live in a line, those who build in a circle, and those who construct spirals. Each of these, more than style of urbanism, proposes a moral of existence. For the first—which Simonds experienced in his early works—the rush forward, the willingness to abandon —he wrote that "when they move, they leave everything behind, intact like a personal museum."[4] Quite to the contrary, people who live in a circle live a myth of eternal return, of cyclical time, of a present inhabited by the past. Their "irreducible idea of the center,"[5] is different from that of the spiral people, for whom the progression is important, despite the fact that their fanatic concern with the past links them to what they have lived. But as their Dwellings demonstrate, each in its own way, they all share the common need for a ritualized existence.

At this stage, where every posture is symbolic, earth herself becomes erotic. She swells, revealing in her breast obscure analogies, unforseeable burgeonings. From 1974 on Simonds's work has taken into account eruptions and turgidities. The constructions are no longer made on the surface of the earth, but are erected out of it, taking form from its most secret depths. The material has become gravid, and it will be revealed in time. This factor, an essential part of Simonds's earlier work, was an intemporal time, a synthetic concept in which were mixed all the stages of the duration. With *Park Model/Fantasy* (pl. 26) a sort of demultiplication takes place: the same site is presented in successive phases, no one phase being pre-eminent. The identity of the site exists only through the sum of its differences, its transformations. Time reveals the true shape of things in the slow process of evolution that makes them what they are.

It is with this series of *Circles and Towers Growing* that Simonds's idea becomes more clearly defined. From the same common trunk emerge two possible developments, that of towers and that of circles; thus within the one family diverse faces are born from the same genes. Only destruction, effacement, eliminates these differences, returning the most elaborated of his constructions to their initial state of unformed material. The history of man is but his return to the earth, in which death traps him.

Simonds's turning away from street works to sculptures was interpreted by some as a renouncement, an integration into traditional art circles. Yet in fact his sculptures form a more elaborated part of the work in the city and lead to a symbolic dimension. Certainly his street works exist in the form of sketches, intuitive notations, and lead to sculpture, but Simonds is also advancing it as a means of contact with the outside, a touchstone of truths. The dichotomy inherent in his work, from social project to the most intimate

piece, is evident in the sudden eruption, in the course of his work, of the *Floating Cities* project. He who tries to interpret it from a sculptural point of view can only be deceived, for *Floating Cities* is a genuine architectural model. Born out of a reflection on the nature of human habitat, *Floating Cities* is presented as a real dimensional project and introduces into its concept the economic and ecological dimensions that are excluded from the universe of the Little People.

Floating Cities reflects Simonds's continual attraction to different forms of life, social as well as biological, his care in apprehending these forms and, through his comprehension, re-creating a new rapport with society. And in this light, the universe of construction with which the name of Simonds is now associated is doubtlessly only provisional, and may well give way, in his work, to any other form of expression that one day seems to him to have the power to express, other than by a fiction, a true insight.

For Charles Simonds, the nature of art is metaphysical in essence. He belongs to the generation of post-minimal artists who cannot content themselves with formalist criteria, but who attempt to discover both the why and the how of art. Today, as for the man who left the imprint of his hand at Altamira, in the motionless movement of art are the same questions, those that Paul Gauguin naïvely wrote on the bottom of his painting: "Who are we? Where do we come from? Where are we going?"[6] To these unanswerable questions, life and art suggest provisional solutions, which are all the stronger since we were not expecting them, but with which we seem familiar from the outset. Thus we have been, at all times, contemporaneous with Simonds's Dwellings.

Footnotes

1
Translated from the French by Terry Ann R. Neff.

2
Michel Tournier, *Vendredi ou les limbes du Pacifique*, Paris: Editions Gallimard, 1972, p. 112.

3
Bib. I 1975, Simonds and Abadie, p. 5.

4
Ibid., p. 61.

5
Ibid., p. 50.

6
"*D'où venons nous/Que sommes nous/Où allons nous*," 1897-98. Oil on canvas. Museum of Fine Arts, Boston.

Three Peoples

By Charles Simonds

Their dwellings make a pattern on the earth as of a great tree laid flat, branching and forking according to their loves and hates, forming an ancestral record of life lived as an odyssey, its roots in a dark and distant past . . .

Occasionally one meets an old minstrel along the paths through the dwellings. People say that as a child he and his parents began a long journey back and that in his endless wanderings he had accumulated an almost total history of his people. He returned with the jumbled and rambling songs which form a blanket of memories from the threads of a growing, listless and venturesome people who have been many places, and done many things. . . .

. . . an old woman who came back from her journey into the past with a vision: what everyone had believed to be a life following an endless line was really part of a great unperceived arc that would eventually meet itself. At that point everyone would join their ancestors in a great joyous dance . . .

—Fragments of Notes Recovered from a Traveler

Their dwellings formed a road/house wandering over the earth on its way towards the future and away from the past. When moved from one dwelling to the next, they left everything behind untouched as a museum of personal effects. As dwelling followed dwelling, traces of a diminishingly distinct personal history remained. Traveling backwards was almost like stumbling into a room whose inhabitants had just left by another door. The farther the distance in time, the more this immediacy blurred; its distinctness dissolved into other moments. Time became continuous. Sand collected in the corners and roof beams fell in, until the earth reclaimed the architecture. Only a trace, an irregularity recalled that someone had once passed here on the way to somewhere else.

 were preoccupied with cultivation and with decisions about the next direction the dwelling might take. Marital agreements, social ties, and economic concerns, the lay of the land, junctures—all these had to be thought about. Bureaucracies rarely developed because decisions were capricious. Paths might intersect or pass near one another, but each dwelling retained its autonomy. Webs and thickets of old and new dwellings emerged, creating strange cities that combined houses with ruins, gardens with parks that exposed personal histories to everyone's view. Intermarriage was common when these joinings occurred; traditions and pasts were traded and lineages mixed.

Reminiscing about these gatherings, saw them as the high points of their lives. Fortified with a feeling of here-we-all-are, moved on. Dense civilizations might occur and then disintegrate while parted and returned to their adventures. When someone wanting to trace their past came upon these intersections he might be unable to sort out the trails and, taking a chance would find himself lost in a confusion of pasts. Occasionally someone who had ventured too far back would turn up on a doorstep— without a past or a present. These people were a source of much pity, having risked all trying to penetrate what came before.

Tours into the past were organized. Teams of specialists—archaeologists, sociologists, anyone who might have a clue to the past—set out on expeditions. Periodically messengers returned with maps documenting some large meeting place of dwellings that had

occurred long ago, and this discovery would be used to explain why certain families had maintained their beliefs, shared genetic traits, where feuds had originated.

For most of the , the past formed a tremendous net on which their lives traveled; or it was like a dark forest into which there were many paths. The past was a temptation and a threat, the begetter of insanities, the cause of endless ruminations and confusions —a mysterious world that might begin happily in the present on an afternoon stroll, but which stretched backwards into a terrifying miasma, a genealogical geography that disappeared over the hill and into the earth, beyond the horizon.

<p style="text-align:center">◯</p>

There is a warning tale—a troubling memory—repeated every year among ◯ of a child who was born unhappily spinning toward the future instead of turning clockwise toward his past. For some time his confusion went unnoticed, and they merely thought he was dizzy and slow in learning to walk. But when he came of age, he joined in the rebirth and was caught in the whirling dance. Suddenly he was spun, wrenched and twisted out of the circle—dying horribly alone.

◯ lives had two aspects: the first was the daily sorting out and keeping of time that placed events in space and history, merging past and present to make both histories and ongoing sagas as well as dwellings that changed according to the seasons; the second was the yearly concentration of birth and growth energy into one ritual at the winter solstice. The first historiographical aspect governed the daily task of reconstructing the new dwelling from the remains of the old. This effort was a recapitulation and reworking of personal memories into myth and history. The second ritual aspect, eschewing all temporal activity, re-enacted original creation in a dizzying celebration of sexual possibility.

The gathering took place in the dome-womb at the center of the earth-dwelling universe that could be entered only by a ladder through the opening at the top. The cyclical dwellings were built around it in two concentric rings: the first, one story high, containing the cooking and eating quarters, the second, usually two or three stories high, the living quarters. A passageway between the inner and outer structures linked the two. Construction advanced the rings, rotating them laterally around the dome. As portions of the structure were abandoned, they were sealed up, to deteriorate, and after one revolution was completed were dug up and rebuilt. Thus the remnants of each previous dwelling were excavated and remade. Life followed a circle.

The structure grew at least one unit a year. Completion of the new dwelling was timed to coincide with the winter solstice so that everyone's dwelling place could be moved forward a unit toward the distant past and one away from the recent. Crops grown outside the dwelling were part of this circular pattern, planted in a rotation around a center.

The dwelling functioned palpably as a personal and cosmological clock, its encircling architecture operating as an elaborate sundial. The annuary poles over the entrance to the dome cast shadows on the surrounding walls in complex and changing patterns, marking the passage of time. Inside the dome a chant was maintained without interruption. Its faint rhythm audibly kept time for those outside. Everyone took a turn. Chanting was meditation, a way of passing into a non-ordinal pulse, unrelated to the particular incidents of life.

The construction of the new dwelling took a year and followed a precise schedule so that the building progressed with the seasons. The continual sifting and sorting of the rubble formed a sort of ouroboros in which the present devoured the past. Some things recovered were collected and reused; some were reminisced over and became artifacts or keepsakes. Stories and memories were woven around these mementos and the past was reconstituted in ◯ minds just as the old bricks were fitted into the new dwelling.

At times, this resurrection of the past was not achieved without some effort. Those who felt a need to wrestle with the memory of the person or event unearthed stepped forward and relived it in the form of a story, a song or a speech, entering a dialogue between the living present and the dead. An entire day might be set aside to settle a particularly disturbing recollection. Once everyone was reassured, the excavation and construction began with rhythmic singing, sifting, and sorting.

Sexual relations supposedly were confined to the rebirth ceremony. There were strong prohibitions against other sexual encounters, and transgressors, if caught, were executed. This repression was intended to channel all sexual energy toward one shared incestuous moment, although in fact it gave rise to heightened daily promiscuity. Surreptitious meetings took place through elaborate and ofttimes humorous subterfuges. Lovemaking in a hidden corridor or through some inventive masquerade of another activity was commonplace. Such behavior was ignored and thus tolerated, as long as it did not result in pregnancy. Self-administered abortions and prophylactic roots, although taboo, were common. Incestuous relations were the goal of such illicit encounters. Even then, they were only a burlesqued version of the imploding/exploding sexual activities of the annual rebirth, and introduced a note of obscene laughter and discord into an everyday life that was otherwise bland and routine. Although the result was supposed to be death, the risk was slight in actuality, and held the fascination of a sexual Russian roulette. Publicly, any one of the ◯ would say sexual activity for any purpose other than conception was incomprehensible, that intercourse could take place only within the sacred confines of the dome, and then only on the solstice; that unless protected by the dome-womb, no conception was possible.

The solstice was the focus of the ◯ lives. As the day approached, excavation ceased and excitement spread throughout the dwellings. Foodstuffs were harvested and a share placed within the new house. At sunset every adult gathered according to age and descended into the dome. Each, upon reaching the bottom of the ladder, placed a log upon the fire at the center, removed and burned his or her clothes, and took up the chant. As the circle expanded the chant grew louder, the fire brighter and hotter. With the entrance of the last person, the ladder was drawn in crosswise above their heads.

Everyone stood hand in hand around the wall in a large circle. The dance of rotation began, whirling into eddies of energy. Mirroring the solar system couples formed and swung each other around the fire. The dance continued, faster and faster, until the fire began to die. Everyone spun, always trying to increase the other's speed. As the womb darkened, they moved toward the center, reeling to the floor. Lost in the void, they clutched for another body to find themselves in orgasm. When ◯ were spent, fatigue having overtaken them, ◯ returned to the daily counting and ordering of time, taking with them each other's potential.

◎ believed in a world entirely created by their own wills, in which nature's realities were of little concern. Their dwelling formed an ascending spiral—with the past, constantly buried, serving as a building material for the future. They obsessively gambled with their resources, the number of inhabitants, the height of the structure. As the dwelling grew higher and higher, it buried the cultivatable land. As it grew fewer and fewer workers were needed for its construction.

◎ aspired towards an ecstatic death. Their goal was to achieve both the greatest possible height and to predict the very moment of collapse, the moment when the last of their resources would be consumed and their death inevitable. They lived for that moment alone. After a collapse survivors would begin anew, tracing out a tremendous spiral on the earth's surface. At the periphery they built a house. The detritus of life

gradually deposited in front of it providing the base for the next dwelling. As time passed, a ramp was thrown up, the rate of incline planned to bring them to the highest possible point at the center of the spiral. As their predictive mechanisms became increasingly accurate and sophisticated, there were constant readjustments, such calculations determined the infrastructure of ◎ social system. Life was hierarchical. The uses of energies were determined by the ruling philosopher/mathematicians. Division of labor, population control, food, size, and disposition of labor and research forces were all dictated by elaborate evaluative and self-corrective mechanisms.

◎ were for the most part optimistic. Although the construction required hard work and sacrifice, they labored happily knowing that the mathematicians' predictions were finer, their dwelling place higher, their lives nearer the climax. They believed resolutely that they were contributing to the most ambitious monument ever conceived by man. Their assurance was confirmed by badges of merit and honors given to the various work forces. Visitors from the spiral cities compared progress with their own and were filled with immense pride at their accomplishments.

The monument relentlessly consumed all material goods. Property had importance only as it related to the construction. Objects no longer useful were by law contributed to the pile of debris at the front of the dwelling. No personal possessions were allowed, no artifacts or keepsakes, no objects of art, no religious figures, no personal or communal decoration; life was merely a function of shelter and height. As the highest elevations were reached, and fewer and fewer laborers were needed to continue, large groups were sacrificed, jumping voluntarily from the forward edge of the structure into the central well, giving their bodies to the task of pushing the edifice higher.

The past, in any personal sense, was dismissed and forgotten. The exception was the carefully kept records of previous structural decisions—abstracted and distilled into mathematical equations to be used in projecting the building. The dwelling's past was reconstructed by a mathematical model to be used in dynamic relationship to its future. These records were kept with compulsive accuracy, because the slightest error might mean the failure of the entire edifice. Failure was, in fact, inevitable so that the work process was punctuated by pangs of doubt that led to depression and, finally, to extinction.

Plates

All plates are illustrations of works by Charles Simonds. An asterisk is used to indicate those pieces that are included in this current exhibition.

Mythologies

The Mythologies embody the basic ingredients and relationships of all Charles Simonds's work. They set up his fundamental orderings of man as first born from the earth, body as man's first home, and then in turn, man's imprinting of the earth with his physical form and from this, shaping his dwellings. Implicit in the Mythologies is the intertwining of two of Simonds's essential creative forces: growth and construction, the natural and the built.

Birth, Body ——— Earth, and *Landscape ——— Body ——— Dwelling* are films of rituals enacted by the artist. In *Birth* Simonds, buried in the earth, symbolically is reborn from it, thus establishing earth as mother and also implying a sexual relationship to clay and earth as material. In *Body ——— Earth* the artist, as first man, uses the movements of his body to contour the earth, creating a small-scale landscape within the larger one, giving back to the earth the shape and scale of himself. In *Landscape ——— Body ——— Dwelling* Simonds transforms himself into a landscape with clay, then goes on to construct a fantasy dwelling on his body, on the earth. With the contours and substance of his own body as landscape, Simonds establishes a unity of body/earth and house/home.

Crucial to an understanding of the Mythologies is the fact that in addition to their existence as films, they are rituals enacted by the artist for his imaginary civilizations. They have been enacted more than once. As the only existing "Little Person," Charles Simonds has done these rituals not only to create works of art, but as a kind of personal experience central to his art. The actual experience of the unities he generates in Mythologies is spiritually refreshing.

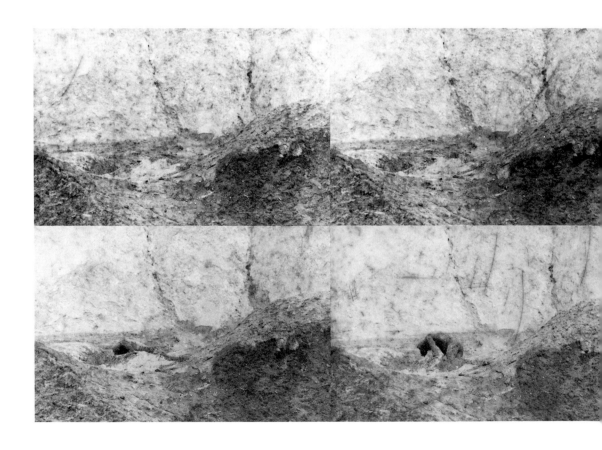

Plate 1. *Birth*, 1970. Photographs.

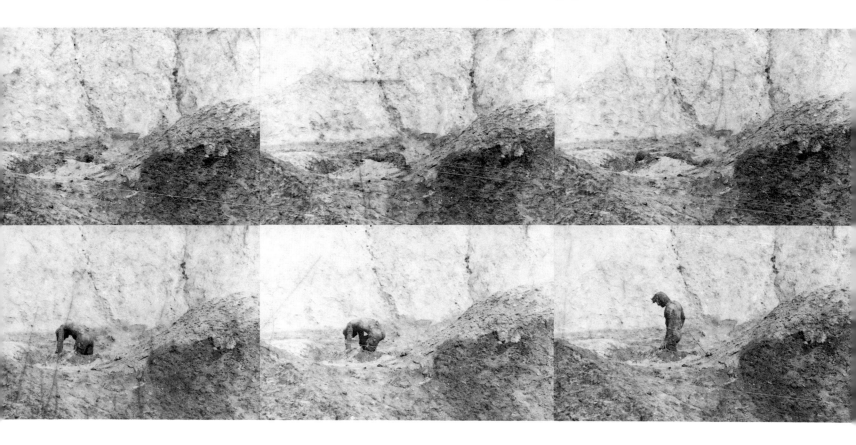

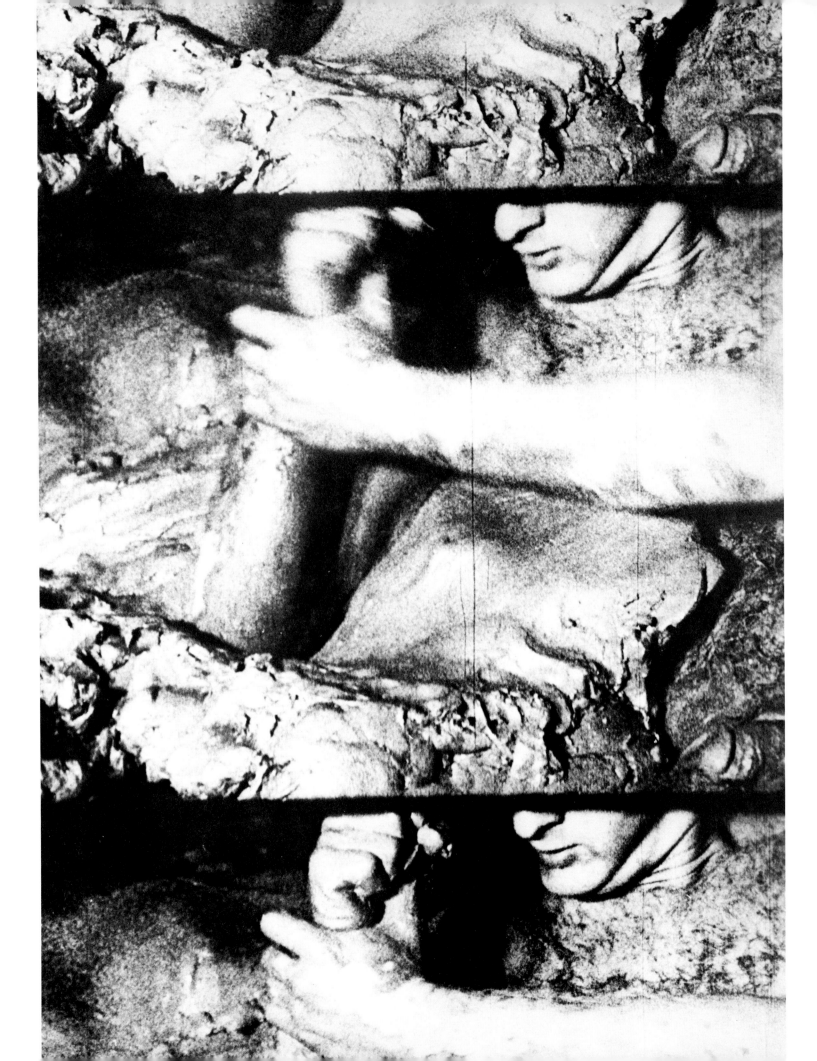

Plate 2. *Body* —— *Earth*, 1971. Stills from the film by David Troy.

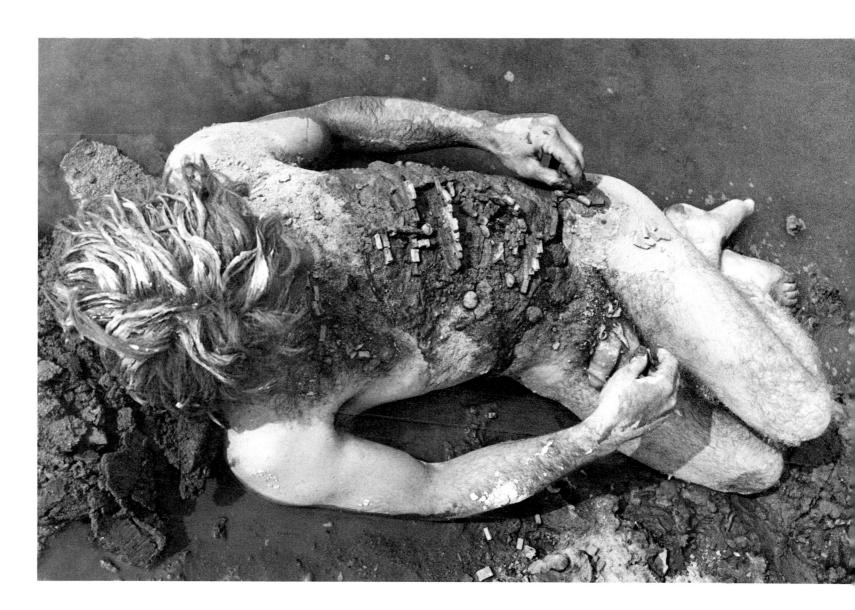

Plate 3. *Landscape* —— *Body* —— *Dwelling*, 1970. Photograph.

Dwellings

Since 1970 most of Charles Simonds's time has been spent constructing dwelling places for an imaginary civilization of Little People who are migrating through the streets of different neighborhoods. The Dwellings are made of raw clay in the streets—in niches in broken walls, vacant lots—wherever the architecture of the city offers them a home. The creation and eventual destruction of the Dwellings is seen as emblematic of lives in an area where the buildings of the city are undergoing constant transformation. New construction, vacant building, rehabilitated building, vacant lot are mirrored respectively by dwelling, ruin, reinhabited ruin, and destroyed dwelling. Each Dwelling is a scene from the lives of the Little People, a different time and place in the history of this imaginary civilization. Landforms originally with body/sexual associations are being transformed by the Little People into architecture. Slowly they are developing their own history and potential archaeology.

By building his Dwellings in the streets, Simonds is engaging in a social activity. He is in constant dialogue with passersby—whether on the Lower East Side of Manhattan or in Shanghai. The street Dwellings reflect their specific locale; they are warped mirrors for given geographical, political, and social times and places. For Simonds they are also his "work in the field." Economic in terms of energy, mass, and time relative to their effect, these holes in the time and place fabric of daily reality furnish him with information about that reality. At the interface between the civilization of the Little People and that of the neighborhood, discoveries travel in both directions.

The Dwellings are made of clay bricks 1.3 cm (½ in.) long.

Plate 4. *Dwelling, Dublin, 1980.*

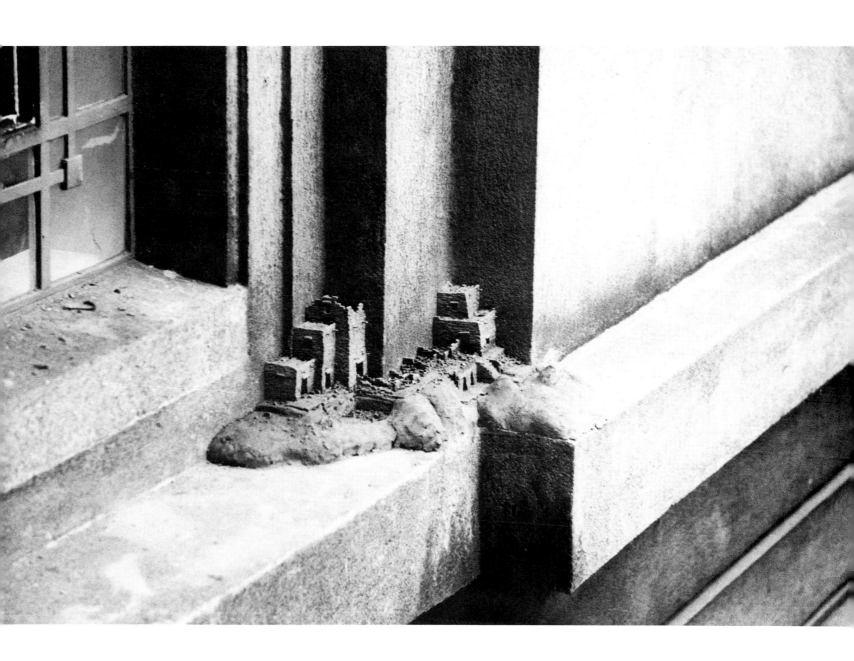

Plate 5. *Dwelling, P. S. 1, Long Island City, New York*, 1975.

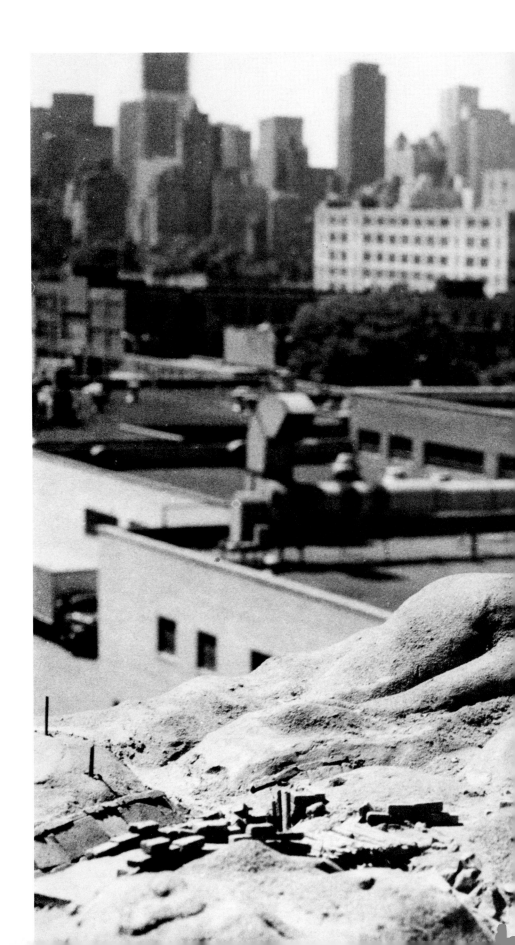

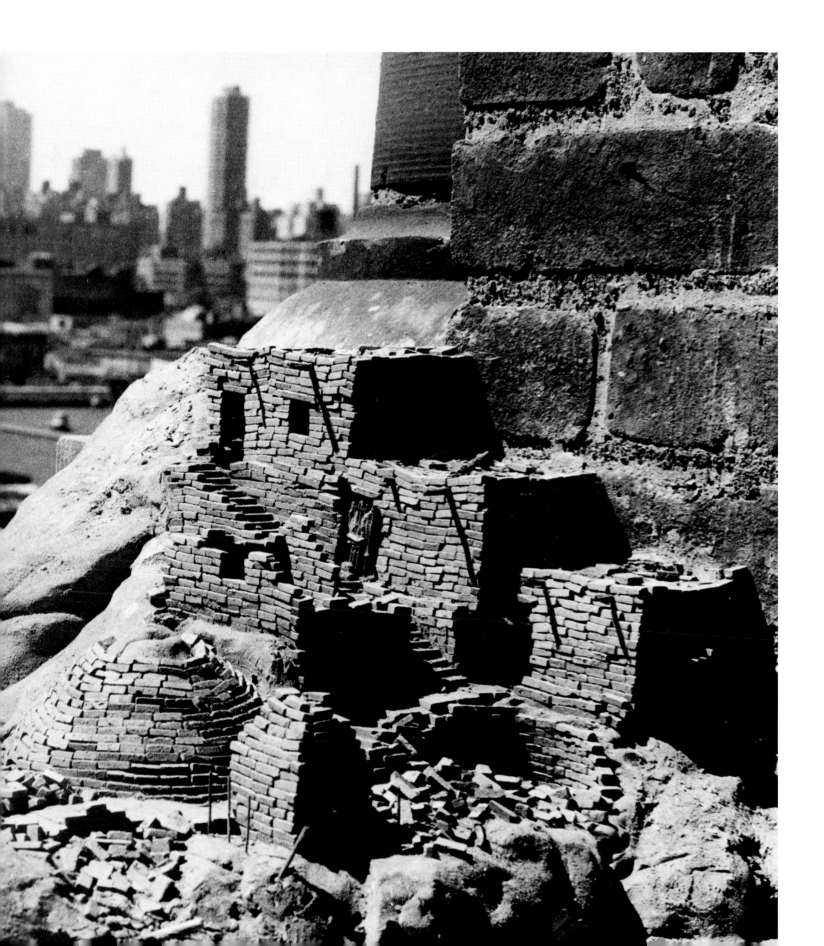

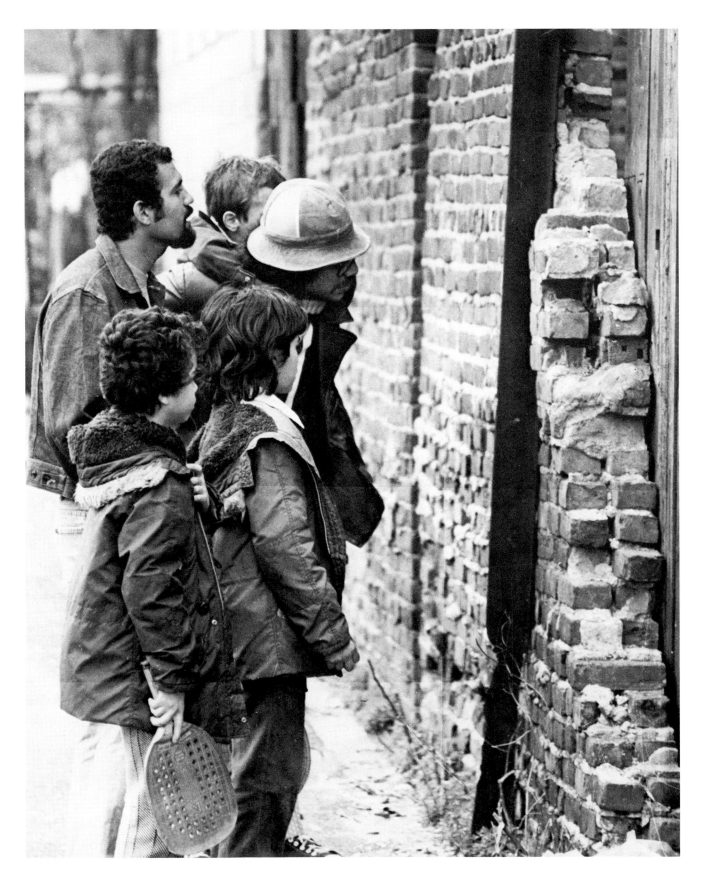

Plate 6. Passersby with *Dwelling, East Houston Street, New York*, 1972.

Plate 7. *Dwelling, East Houston Street, New York*, 1972.

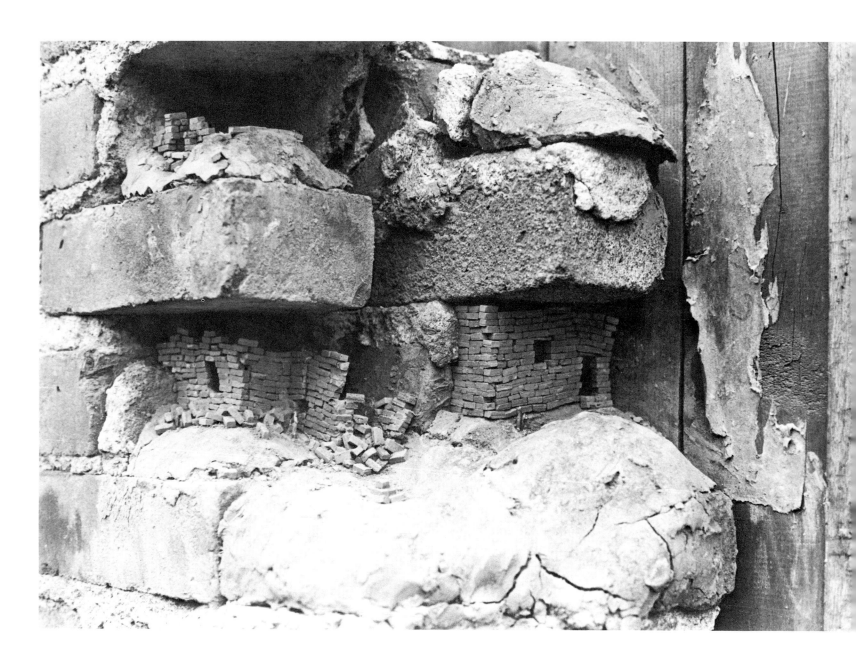

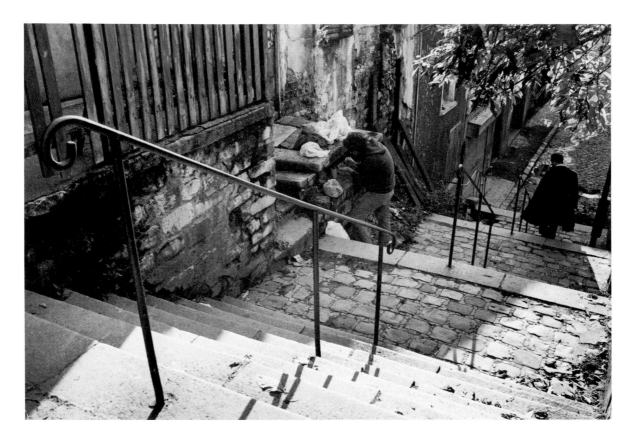

Plate 8. Charles Simonds building *Dwelling, Passage Julien La Croix, Paris,* 1975.

Plate 9. Charles Simonds building *Dwelling, Passage Julien La Croix, Paris,* 1975.

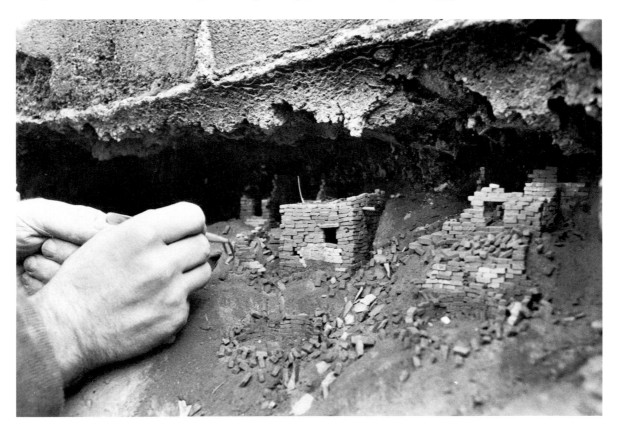

Plate 10. *Dwelling, La Biennale di Venezia,* 1978.

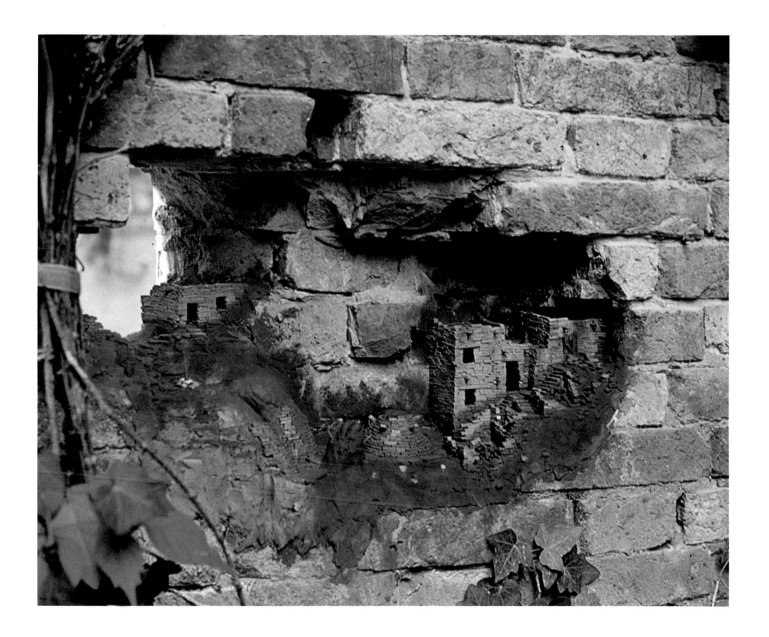

Plate 11. *Dwelling, Kunsthaus Zürich,* 1981. Collection of the Kunsthaus Zürich.

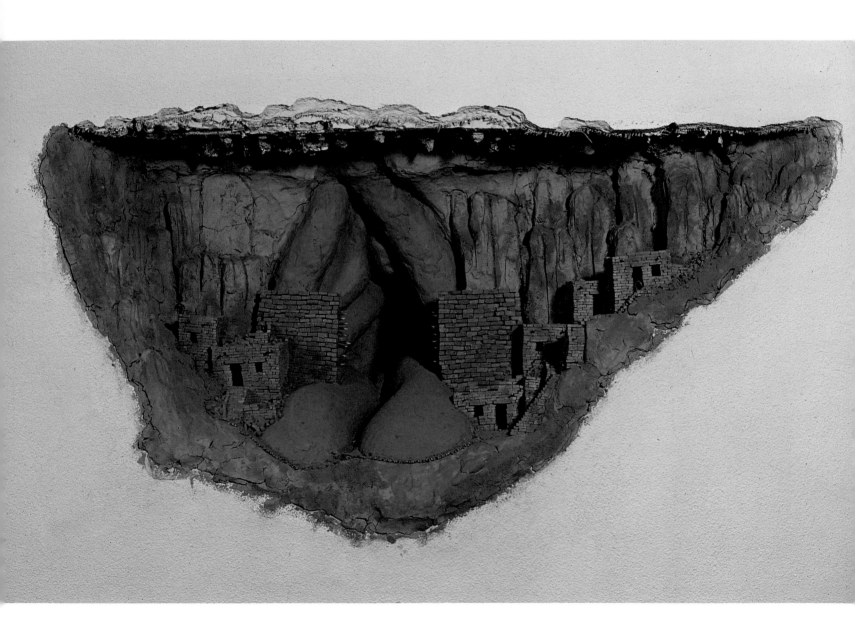

Ritual Architectures and Cosmologies

These are horological architectures—a series of living structures that measure time. In part they are distillations from the information gathered and experienced by the artist through his activity of building Dwellings in the streets. But these are abstracted, conceptualized architectures that exist in their own space, apart from everyday, built reality. Some of these works are attempts to make architectural emblems for particular body/life functions, for example, *Labyrinth* (pl. 16) symbolizes seduction. Formally and functionally they examine the metaphoric relationship between body and house, the grown and the built.

The Three Peoples explore architectural structures that are a reflection of their beliefs about their relationship to the past and future. The People Who Live in a Line construct an endless house that wanders over the land. Oriented directionally, their continual explorations leave their past behind as a museum. People Who Live in a Circle have a compelling sense of a center. They constantly excavate and reintegrate their past into their present; memories are transformed into myths. Orientation is determined by the seasons and by chance occurrences (fires, family arguments, etc.). Their architecture operates as a personal and cosmological clock. People Who Live in a Spiral bury their past beneath them and use it as building material. The mathematical philosophy revolves around speculation as to when their death and the inevitable collapse of the dwelling will occur. They are conservational, anal, materialistic, proud, and monumentalizing, with a fixed point of view.

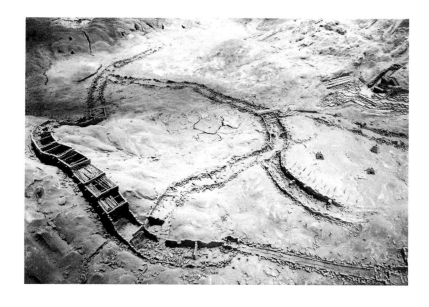

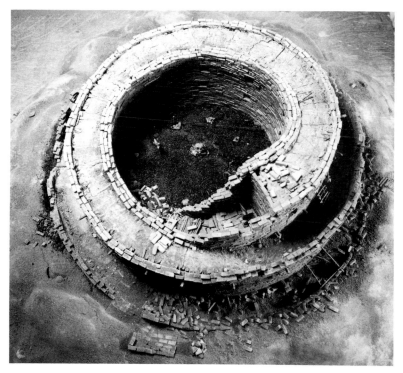

Plate 12. *Picaresque Landscape*, 1976, detail: *Linear People*. Installation at the Museum of Modern Art, New York. Collection of the artist.

Plate 13. *People Who Live in a Spiral*, 1974. Collection of the Allen Memorial Art Museum, Oberlin College, Oberlin, Ohio.

53

Plate 14. *People Who Live in a Circle*, 1972. Collection of the
Museum of Modern Art, New York.

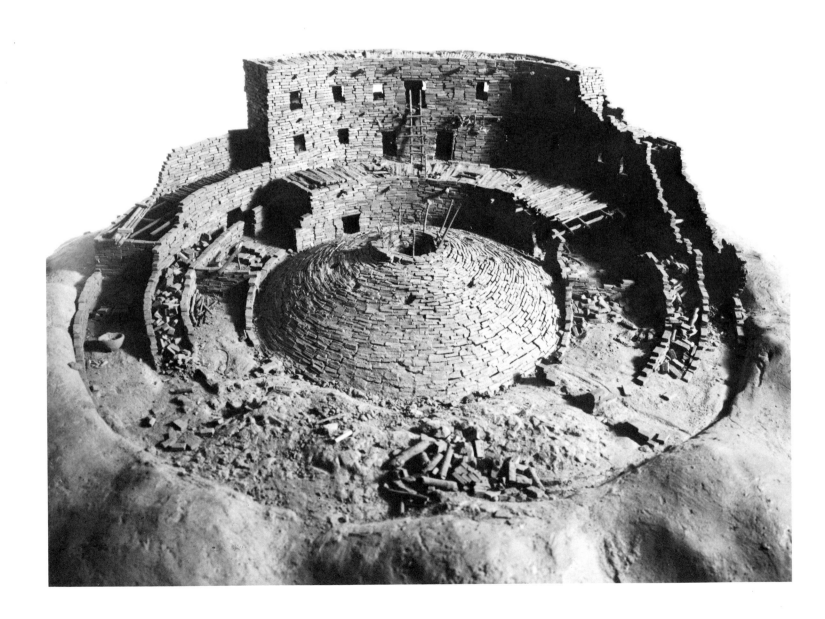

Plate 15. *Pyramid,* 1972. Collection of Susana Torre, New York.

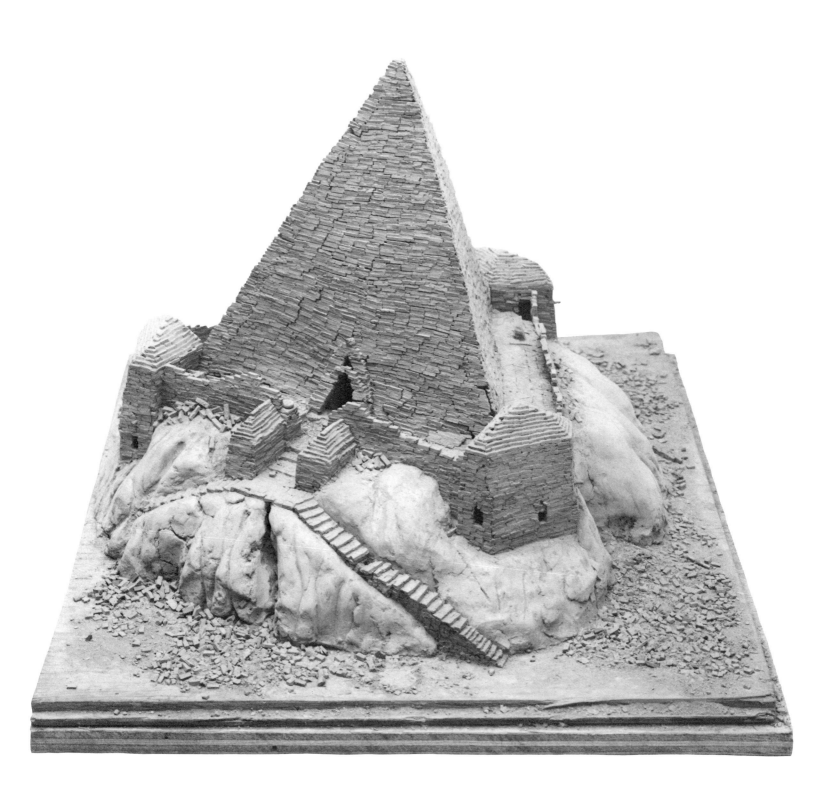

Plate 16. *Labyrinth*, 1972. Collection of Harry Torczyner, New York.

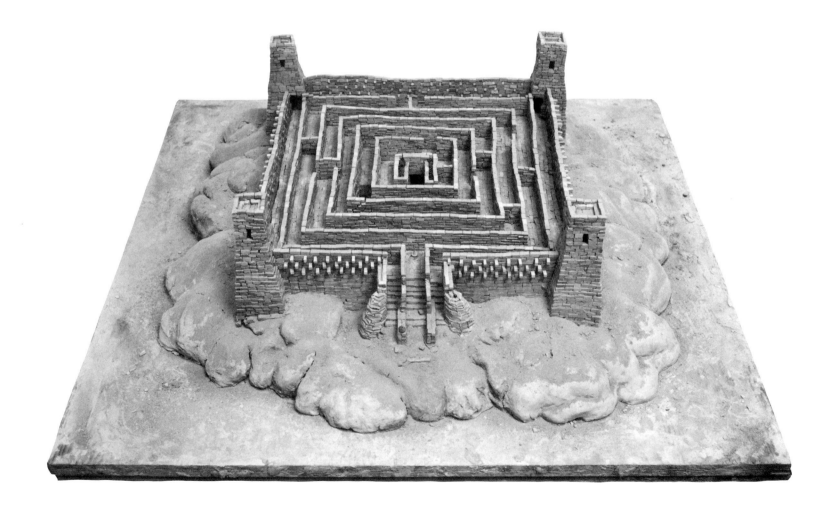

Plate 17. *Abandoned Observatory*, 1975. Collection of the Centre
National d'Art et de Culture Georges Pompidou, Paris.

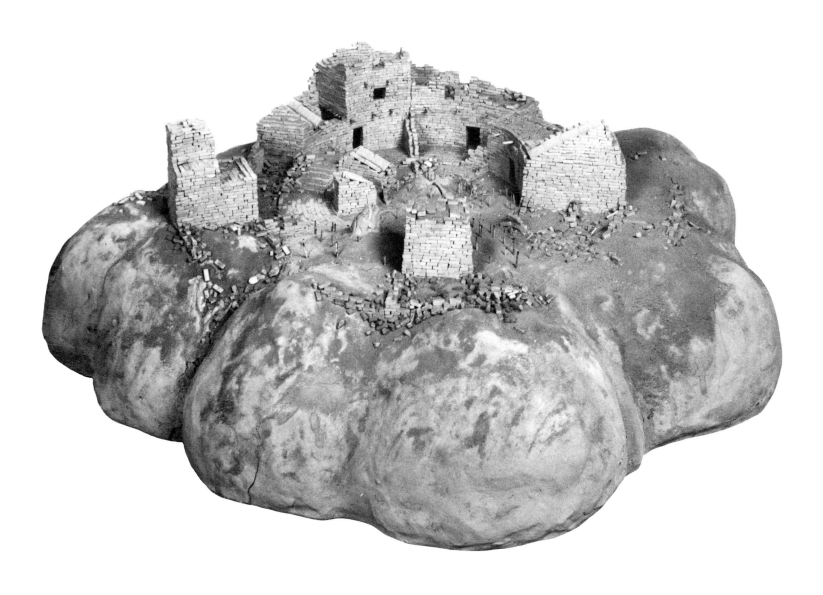

Plate 18. *Gate of Souls*, 1981, detail. The Feiwel Collection, New York.

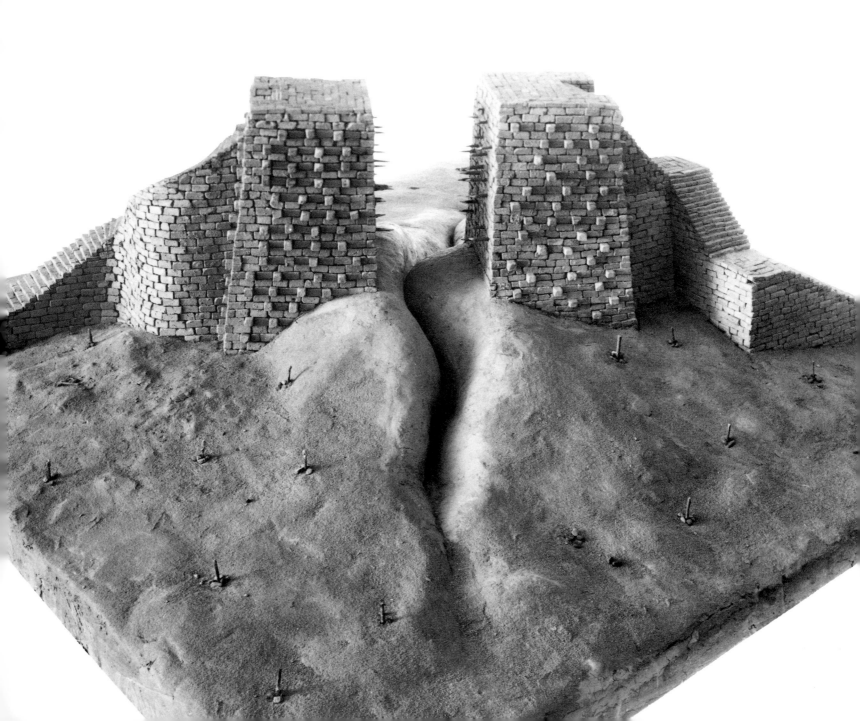

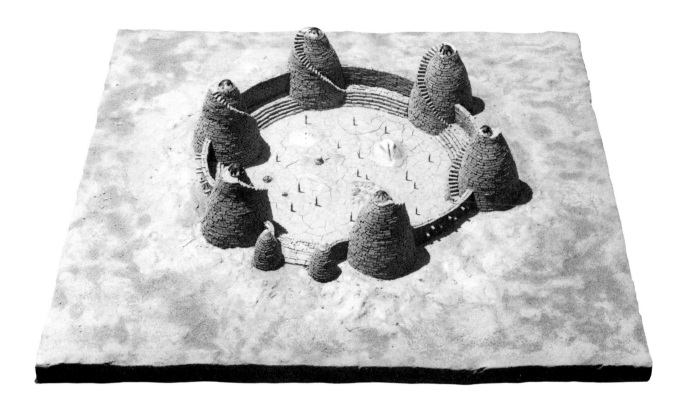

*Plate 19. *Ritual Garden,* 1980. Collection of the Museum of
Contemporary Art, Chicago. Exhibited in Chicago
only.

Plate 20. *Justice,* 1981. Collection of the Handlers, New York.

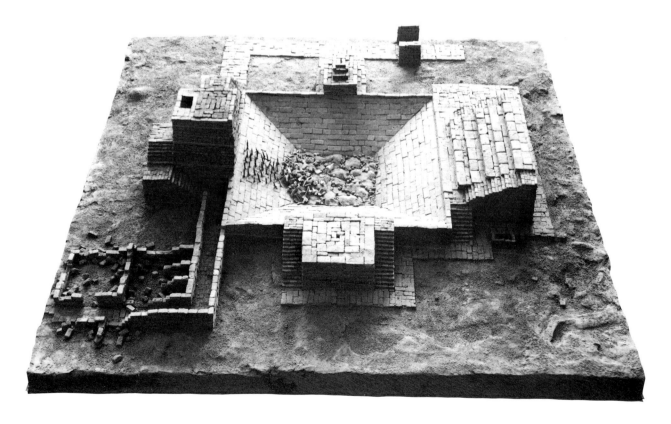

" △ ," Temenos, Birthscape

These installation works bring together in one time and one place, for the purpose of viewing, different moments and evolutions in the history of the Little People. (This type of simultaneous presentation which Simonds calls the "picaresque," contrasts with the viewing of the same place at different moments in a sequence of separate landscapes, such as *Circles and Towers Growing*.)

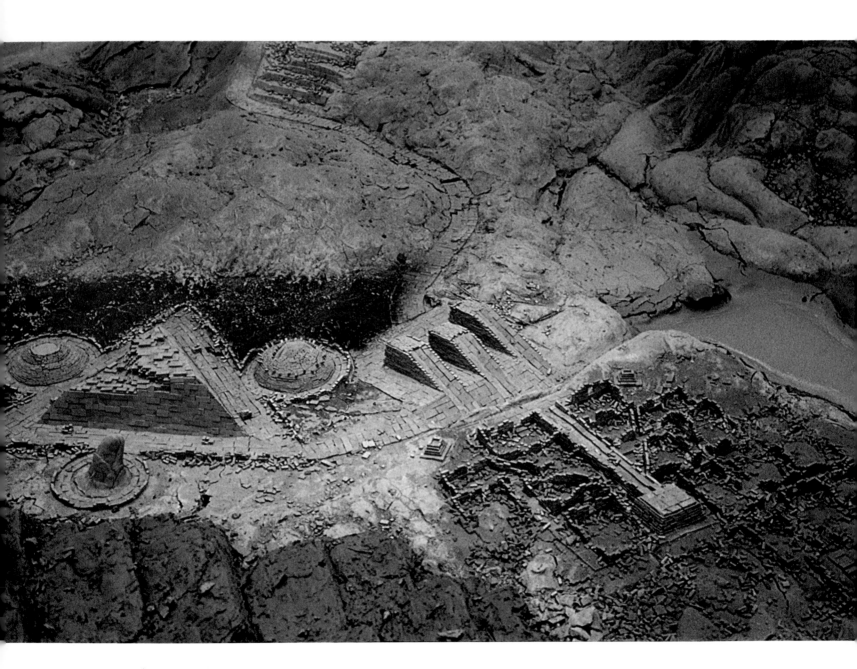

Plate 21. " △ ," 1977. Installation at "Documenta 6," Kassel, West Germany.

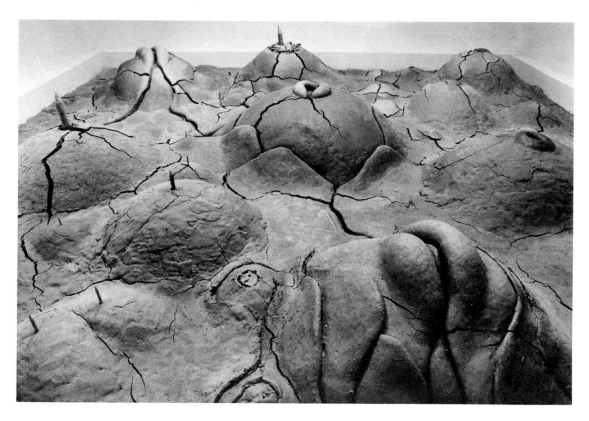

Plate 22. *Temenos*, 1977. Clay, stone, and sticks; approx. 6.1 x 5.5 m (20 x 18 ft.).
Installation at the Albright-Knox Art Gallery, Buffalo, New York.

Plate 23. *Birthscape,* 1978. Diameter approx. 4 m (13 ft. 1 in.).
Installation at the Stedelijk Museum, Amsterdam.

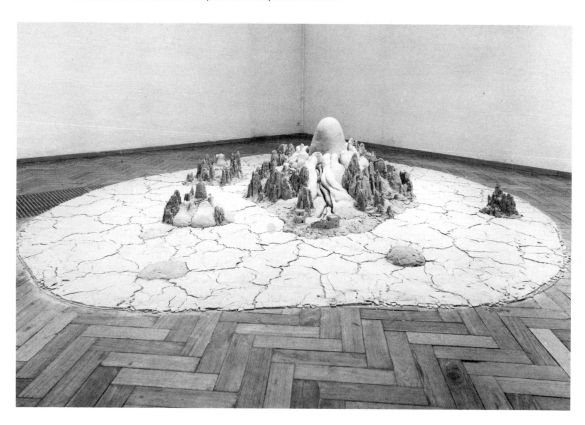

Niagara Gorge, La Placita, Park Model/Fantasy, Stanley Tankel Memorial, Growth House

In these projects Simonds has sought to integrate the insights and values generated through his Dwellings and Cosmologies into full-scale social situations. These are community projects that involve participation. Rather than object or monument-oriented, these are process-oriented works that involve the structuring of real people. In his translation of concepts explored and developed in imaginary and thus controlled situations, to a real social context, Simonds achieves an actualization of possibilities formerly only theoretical.

Plate 24. *Excavated and Inhabited Railroad Tunnel Remains and Ritual Cairns, Niagara Gorge*, 1974. Installation at Artpark, Lewiston, New York.

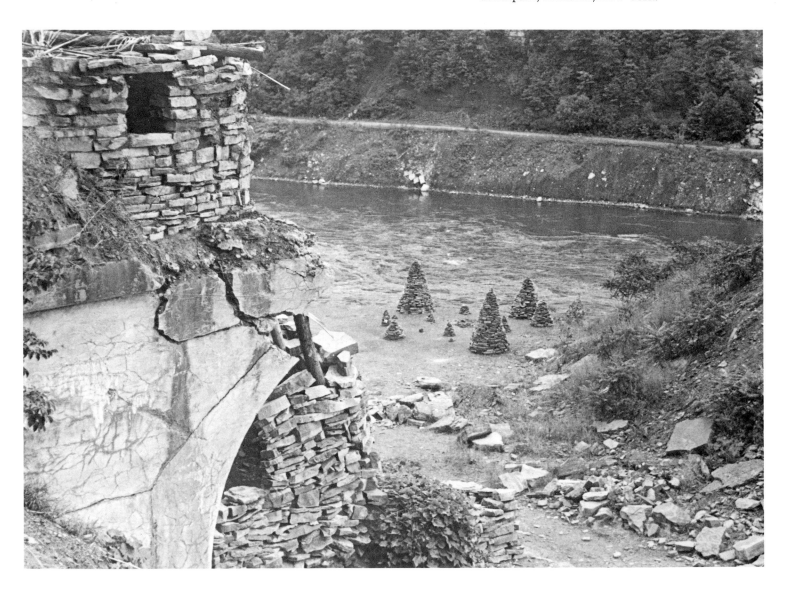

Plate 25. *Park-Project Uphill, La Placita, New York*, 1973. The creation of a park-playlot sculpture from a vacant lot done in cooperation with the Lower East Side Coalition for Human Housing, the Association of Community Service Centers, and the Young New Yorkers.

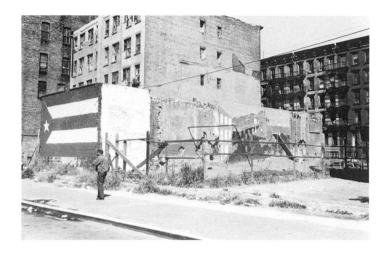

Plate 26. *Park Model/Fantasy (No. 2)*, 1974, detail. Clay and photographs; 50.8 x 76.2 cm (20 x 30 in.). Collection of the Wallraf-Richartz Museum, Museum Ludwig, Cologne. The remains of a group of people the geometry of whose architecture was at a 45° angle to the axis of the city. Part of a semaphore village: three models presenting three different periods in its history. The side walls reflect the coordinates of New York and represent a through-the-block lot on East Second Street between Avenues B and C. The dwellings were built along a continuous line of habitation. Signals were sent from house to house by means of a tower, and each family was responsible for the maintenance of its fires. In this second model the dwellings and towers are abandoned, and only parts of a ritual place are still used.

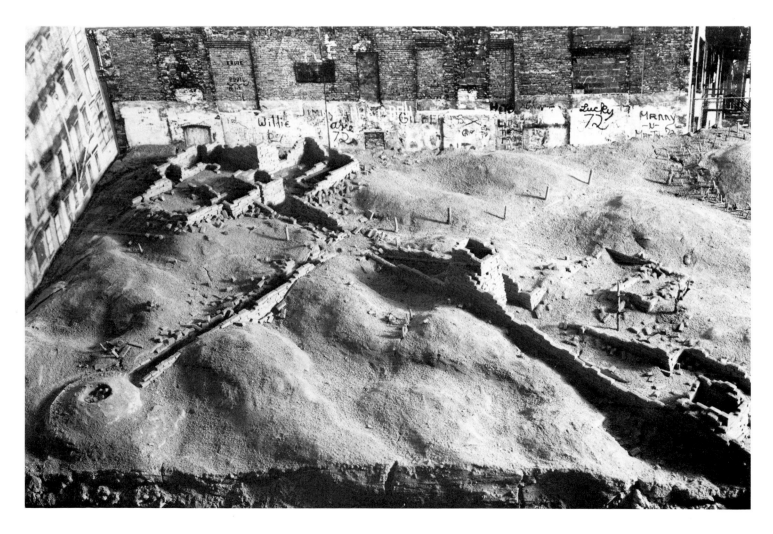

63

Plate 27. *Proposal for a Stanley Tankel Memorial Hanging Gardens in Gateway National Park, Breezy Point, New York*, 1976. Ink on photograph. Collection of the artist. The transformation of two city housing projects that were halted in mid-construction by citizens' protests organized by Stanley Tankel, into a memorial for his efforts to preserve the natural landscape surrounding New York.

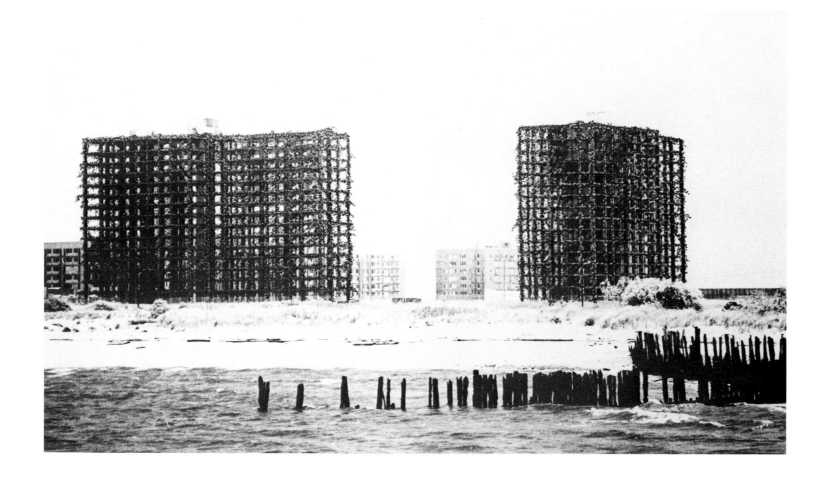

Plate 28. *Drawing for "Growth House,"* 1975. Pen and ink on
paper; 63.5 x 74.9 cm (25 x 29½ in.). Collection of the
artist. *Growth House,* a seasonally renewable dwelling.
Constructed of earthen bricks filled with seeds, the
dwelling is converted from shelter to food that is
harvested and eaten.

Floating Cities

Charles Simonds's *Floating Cities* are changing constellations of social and economic land units transferred to a water site. Although planned and managed, these maritime communities have the flexibility of a natural system, with the ability to divide and multiply their configurations much as an organic, cellular structure. This work is conceived as a critique of existing traditional economic notions of property. Simonds views these futuristic communities as alternative modes of living. Free to travel the oceans, the inhabitants would develop an economy based on their unique relationship to the sea and their transitory interaction with fixed, land-based communities. The *Floating Cities* themselves would alter in time, both reflecting the defining characteristics of the inhabitants and, conversely, shaping those very characteristics as the alteration of the site produced altered states of spatial orientation.

Simonds's photomontages of the *Floating Cities* indicate some of the endless possible arrangements of units.

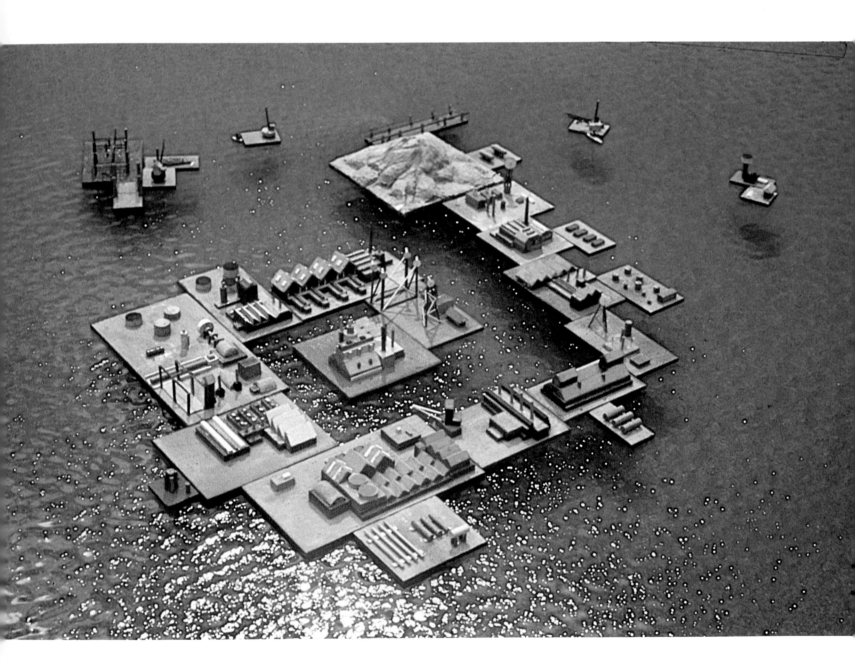

*Plate 29. *Floating City Model*, 1978. Painted wood; dimensions variable.
Collection of the artist. Exhibited in Chicago only.

Plate 30. *Sketches for Floating Cities,* 1978. Pencil on paper.
Collection of the artist.

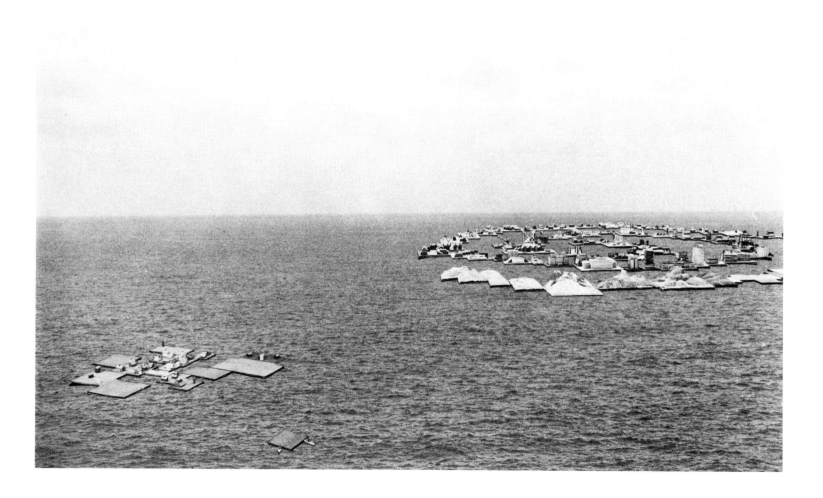

Plate 31. *Floating Cities Photomontage,* 1978. Collection of the artist.

Circles and Towers Growing

This series traces a possible and fairly comprehensive evolution of the Little People's world and their use of it through ritual and architecture.

Commentaries

By John Hallmark Neff

Number 1 (pl. 32)

This is the beginning—that is, that point in the landscape's evolution that the artist has chosen to show us first. We infer what has gone before from what remains. There are few topographical features, no presence of life forms. The surface is slightly rough and the crust is broken by irregular networks of cracks, some fine, others coarse and deep. The pattern is not that of a window, smashed but still intact, with the lines radiating from the point of impact. Rather, the lines are peculiar to a horizontal surface drying at different rates according to the depth of the water, the intensity of the heat, and the malleability of the earth. The image is of a land once submerged, now recently revealed, a *tabula rasa* upon which the landscape can begin to assert itself.

We are unsure of the age of this first frame of Simonds's landscape. There are no fossils, no reptilian tracks—it could be the summer mud of a housing tract in Illinois. Yet we know it is meant to be old, the water only just absorbed and evaporated, leaving the earth dry, anticipating change.[1]

Number 2 (pl. 33)

If the first landscape results from the surface action of sun, wind, and water upon the land, the second seems to represent a moment when forces from deep within the earth surge to the surface, erupting in shallow elliptical domes above the crust. The hypogene swellings are irregular in size and shape but share a diagonal orientation across the fundamental square. Some of the rounded hills are topped with smaller mounds or fissures; some are open, connectives to the interior heat; others are already smooth and cooling. Now visually differentiated— the basis for fixed points, then axes and orientation—the landscape becomes a specific place: here, not there.[2]

Number 3 (pl. 34)

The third landscape shows for the first time signs of habitation. Two pathways beginning near opposite corners (but not precisely at the edges) meander over the earth's contours, curving around the shallow domes. One path appears to terminate at a pole, taller than the others that form a loose circle around one of the swelling mounds. The poles mark areas of ritual activity. Since *Number 2*, the swellings have been further accentuated by small rings, fissures, and nipplelike buds. Others have been capped with colored stones. Reddish-orange sand in the concavities or valleys further differentiates this half from the less-evolved yellow section where the water has receded further to a single arid quadrant.

The third landscape also shows us the first signs of future directions; it is from the domes and the phallic tip erupted from within the folds at center that the Circles and Towers respectively evolve: all the possibilities are here. The dualities of sex, female and male, are thus established early, the one implied before the other, as the generative forces that determine the course both the Circles and Towers follow during their evolution. As Simonds specified,[3] the work follows the evolution *both* of a landscape and of an architecture, the one identified with earth, water, growth, nature, the horizontal, female; the other with ordering the earth, fire, construction, erection of the vertical, and male. During the cycle the earth "is digested into architecture," and eventually "all landscape things have become built things."[4] What grew becomes built.

These simple, rather fundamental dualities are established in the third landscape but without being codified into fixed laws. Here is both juxtaposition and ambiguity of genders—are the protrusions on the domes nascent phalli, nipples, lips or womb? Although the question is not really answered—the Circles and the Towers are offered as two possibilities—we sense that the idea of dualities underscores the mutual give-and-take of existence, the importance of a dynamic balance of forces. Neither gender is entirely absent in the 12 landscapes—the principle of evolutionary growth for higher life-forms assumes the variety ensured by sexual reproduction.[5] The degree to which one or the other dominates, however, is the key to inferring whether a particular landscape is in balance, and, if not, what this may mean: is the structure and/or its details becoming more complex—attaining a higher level of civilization—or is it in stasis or decline? If the Circles (feminine principle) are nevertheless all constructed (male), not grown (female), is the structure or process organic and therefore female in emphasis, or simply additive? Does the construction reinforce the forms of the landscape or deny them? Thus the primary image of the hermaphrodite discussed above also functions as an elaborate ecological metaphor, this time reading nature and civilization; or again, that which grows and that which is built, found or structured. Such are the terms, both the obvious and the less familiar, and the kinds of questions one must ask, because in Simonds's civilizations, as in traditional cultures, most everything—each detail—relates to a larger whole.[6]

Number 4 (pl. 35)

The fourth landscape is the first of the Circles that we see following up on the possibilities established in *Number 3*. Discounting the wooden paths and ritual markers appearing there, this fourth landscape shows the first evidence of actual construction. Most of this activity occurs near the center, on the central dome now covered with multicolored bricks in a random pattern with annuary poles placed in the masonry to catch the first rays of the sun on specified days of celebration. Some of the smaller domes also have been modified for habitation.[7] The orientation of their rectangular doorways suggests the daily patterns of family groups or other affiliations which we infer from the clusters of isolated openings; all are turned away from the sacred center. Three new elevated masonry structures have also appeared corresponding to three corners of the square; the fourth holds an isolated phallic mound. All three structures are surmounted by what appear to be troughs angled down towards the central opening; like the annuary poles, the sightlines established by the elevated structures are to be viewed from within the central dome: all are aids to observing celestial events. A single worn, curving pathway leads from the edge of the yellow quadrant—the receding water—to the triangular doorway of the major dome. All but three of the natural domes have been adapted or totally transformed into architecture, but these three are still ringed with ritual markers. Although the dominant forms are circular and smooth, the incision and erection of angular geometric shapes have greatly altered the feeling of the landscape. Triangulated between the raised structures, the domes no longer blend easily with the flat land, as the hard replaces what was soft.

Number 5 (pl. 36)

If the time between *Numbers 3* and *4* assumed a relatively modest span of years, we infer that a civilization has already come and started to decline between *Numbers 4* and *5*. In the former everything seems if not new, then of recent origin and in good condition; by *Number 5* we must become archaeologists to deal with a complex of buildings in obvious disrepair, abandonment, or ruin.

Working outwards with the construction, we see that the central dome has been at one time almost completely surrounded by two concentric rings of buildings; the traces of a third ring extend toward the siting structure adjacent to the small stream and elaborate sluiceway. (In his account of the People Who Live in a Circle, Simonds describes the different functions of similar rings; see p. 36.) It appears that these elevated structures have been enlarged according to the height of the intervening walls. Small natural domes, now almost completely bricked over, are still intact within the inner ring.

Comparison shows that certain details in *Number 4* have become highly structured in *Number 5*, almost in the manner of symbols. The protruding lips of the dome/womb in *Number 4*, for example, are now formalized in an abstract circle of stone. And the random integration in the central dome of multicolored bricks from different areas of the landscape is now a sophisticated spiral pattern unifying the individual red, yellow, gray, and pink buildings which constitute the complex as a whole.[8] Bricks dominate the landscape and only a small natural protrusion (significantly in the small red/pink dome) reminds us where we began. The central dome and the siting structures are well-maintained, however, suggesting that whatever else may have happened to the Little People during this phase, the underlying cosmogony and rituals are still in some form preserved.

69

Number 6 (pl. 37)

All of the Circles and Towers are imaginary moments which do not deny limitless possibilities occurring between them, before or after, or around them in all dimensions. *Number 6* then is another potential extension of *Number 4*—the basic Circle—and an *approximate* parallel development to *Number 5*. None of the Circles and Towers are simply equivalents to one another, hence they are displayed in an offset, staggered configuration.[9]

The most immediate difference between *Numbers 5* and *6* is that the latter has no trace of the three viewing structures. It is as though these had never existed, or they had long since been removed (such as the vestigial phallic tip which disappears from *Number 4* to *Number 5*).[10] The high walls of the outer ring of buildings may account for this. Although both Circles are in partial ruin, the unified arc of both rings in one half of *Number 6* suggests the situation is under control, part of a plan. In *Number 5* the basic unity of the circle is disrupted by divisions into segments so small as to read as rectangles. In *Number 6*, however, the gradual flow of the rubble around the circle also suggests a progressive and purposeful abandonment, as does the new construction beginning just beyond the high point of current habitation. (See "People Who Live in a Circle," p. 36.) Of particular interest again is the central dome, now entered solely by a ladder through a liplike opening on top[11] and comprised of colored bricks randomly ordered and in need of new jointing. In contrast to more formal markers in *Number 5*, stand a stark tree trunk and jumbled logs.

Number 7 (pl. 38)

This moment in the imaginary evolution of Simonds's universe refers most directly to what we know from *Number 5*. Now there are no apparent shelters suitable for habitation, so it is unlikely that we are viewing the landscape at a stage of penultimate demolition prior to rebuilding. The site appears abandoned, perhaps scavenged for materials.[12] The central dome is blocked, the interior seemingly filled with refuse which precludes its collapse. Around the periphery the solid masonry of the celestial sighting structures has so far defied the elements; it is improbable that they contain anything to steal. As the last structures to be built (taking their cue from the inner dwellings), they and one small dome alone remain among the ruins with their integrity as constructions intact. Architecture—in the sense of defining interior space—has effectively ceased to exist.

There are no obvious causes for the desolation, no blackened bricks, nor ash. A yellow smear broader than before suggests high water. But in Simonds's landscape without seasons—without leaves, without clouds—we can infer no weather, no natural cataclysm nor its timing. We have only the annual rings of walls whose upward growth lies unrecorded and scattered at their base.

Number 8 (pl. 39)

There seems to be little here to mark the passing of a civilization—no apocalyptic broken columns, silent grassy mounds, or rusting machines. But the landscape is far from empty. A pale structural shadow of strewn bricks picks out where walls have gradually eroded into dust. The imprint is scarcely there, a slight texture toward the center. The balance has swung back to nature which reasserts its own order. This is not, however, a simple return to a beginning: the topography cannot grow itself over again; time has moved on. Nor is this the end: we know there must be stages yet to come which will obliterate utterly each geometric piece and digest it in turn again to clay. By leaving us at this moment Simonds keeps the future open. For all we know the Little People may return and transform the earth once more into their model of the universe. Or they may not. But this we are left to imagine.

Number 9 (pl. 40)

This landscape, containing the first of the Towers, should be compared with its direct source in *Number 3* and its approximate counterpart among the Circles, *Number 4*. The different principles that apply to both strains are apparent, such as the focus of the Towers at one central point and their consolidation and vertical extension from the center in terms of a definite hierarchical order. We sense their common origin, but are also aware of differences in kind as well as of degree. Having followed the clues for water from Circle to Circle, we are nevertheless unaware of its presence in *Number 9*. There is only the glowing reddish-orange surface from which swell the familiar pale pink domes, folds, and protrusions; the most important difference is that here more phallic buds emerge than before.

At the center the earth is pink and fresh, still in the process of bringing forth a sequence of telescoping folds, like new buds on a plant. From the topmost fold pushes a rounded tip so deeply cleft as to suggest further possibilities of division and metamorphosis. Four similar eruptions in various stages of development bracket the center "tower," which is further set apart by a low curving terrace wall framing six shallow domes symmetrically disposed like sepals or petals around its base. Of these domes three are topped with sharpened poles bent sideways like hooks; the three alternating domes are cleft with slight indentations.

At this stage in the Towers' evolution, then, that which grows is framed and thereby organized, but is not yet overlaid with bricks, save for the cool gray terrace, shallow steps, and deeply curving pathway (set in blocks aligned to an invisible diagonal at odds with the square). Beyond the flowing wall, out around another dome, we see encircling ritual poles and other stakes placed with less apparent plan. This landscape is ordered, identified, coexisting. The vibrant color and slow curves of this floral fortress belie its imposed symmetry. We can still imagine that it grew.

Number 10 (pl. 41)

From the first view of the Towers to the second we witness a direct extension, a more formal structural elaboration of the seven towers now resting upon a congruent (though technically wider) base. Beyond the low walls a reddish zone fixed by ritual markers encircles the complex, separating it from a brown, dusty surface from which nearly every feature of the living landscape in *Number 9* has been effaced. All attention has been directed to the center tower.

One approaches this tower circumspectly by means of a pathway, now slightly curved, which leads up to and over the low wall and connects with a steep bank of stairs spiraling up the left side and around to the back of the tower, terminating in a smaller cone which holds the ritual fire. The straight poles jutting out from the upper masonry link the central tower to the three smaller domes capped with vestigial buds, the only direct reference to the site as the Little People first saw it. But here again it is a matter first of emphasis, not exclusion: the fire altar also shares its gray color with the other three smooth conical-topped towers. These three, like the corresponding domes in *Number 9*, are pierced by sharp angled stakes. (The artist sees these details as violent images, implying things hanging from the stakes as though sacrificed.) The masonry used throughout appears to be a rough gray stone quarried from a source we cannot see.[13]

Except for the rounded swelling of the towers and the details noted above, there is little softness or color in these buildings to remind us of Mother Earth; no doorways or windows to suggest that anyone actually lives within the sacred precinct; or that this is more than a specialized ritual architecture used only on specified days by priests. Between the grown and the built there remains only a brittle equilibrium, one literally of form, not substance. For the most part the earth is left down below, outside.

Number 11 (pl. 42)

In *Number 11* nearly everything which was round in *Number 10* is now square, sharp-cornered, angled straight and true.[14] The organic has become geometric, the flower a crystal. The architecture itself quickens the pace of the central event. The pathway, for instance, in these three sequential frames (*Numbers 10-12*) has been progressively straightened (and likewise the steps), so that now one directly ascends the front face of the hexagonal tower up to the chamber upon whose roof we discover the only circle remaining in the complex, that of the inner altar itself. Even the six square towers are now nearly identical, save for the ritual poles. The masonry, too, seems distinguished by larger, more squarish blocks. The towers appear well-maintained, but the wall—now higher than before and physically separated from the squared plinths of the towers—is crumbling: its complex outline is blurred by courses of stone fallen both inward and outward upon a reddish sand which itself gradually fades further out into a rough pebbly land encircled vaguely with poles. We infer from this wall and its flanking entry gates a protocol, but by whom this is observed (or contested) we do not know.

Number 12 (pl. 43)

This last frame of the imaginary evolution of a landscape concludes what the artist presents to us, but it answers no questions. There are no surprise endings, no conclusion. What we see of the final Tower corresponds not to the preceding Tower, but to *Number 7*, the penultimate Circle. Simonds denies us a neat symmetry with its implications of ultimate unity and order. Instead we read the outline of the towers and fortifications from the shadows of fragmented walls and the pattern of blocks crumbling where they fell. Not a solitary pole commemorates this place. The ruins seem familiar—the ring of six square towers, the stone flower returned to earth. But the structure's center, its gender, is in doubt: whether circle, hexagon, or both (one erected over the other?) we once again must imagine. (Near to the ground the two strains are not dissimilar.) All we know with certainty is that again there is more to come, if only the wearing down of each block to dust.

Footnotes

1

The painter Giorgio de Chirico recalled in 1919 "the strange and profound impression" made upon him as a child "by a plate in an old book that bore the title *The World Before the Flood* The plate represented a landscape of the Tertiary period. Man was not yet present. I have often meditated upon the strange phenomenon of this absence of human beings in its metaphysical aspect" (Giorgio de Chirico, "On Metaphysical Art," reprinted in *Metaphysical Art*, Massimo Carrà, ed., trans. Caroline Tisdall, New York: Praeger, 1971, p. 89).

2

What Simonds does visually in the second landscape is similar to the description of sacred space in Mircea Eliade's *The Sacred and the Profane: The Nature of Religion*, New York: Harcourt, Brace & World, Inc., 1959, particularly pp. 20-24. "The discovery or projection of a fixed point—the center—is equivalent to the creation of the world" For Eliade's "religious man," the fixed point (from which follows orientation in the midst of a chaotic world) is revealed in a hierophany, or "the act of manifestation of the sacred." Once established, the center becomes the point of reference for all activities and literally "the center of the world," "the navel of the earth," and similar names from many different cultures. It is from an understanding of such basic principles that Simonds proceeds to model his own interpretations of these cosmological images.

3

See author's essay above, p. 15.

4

From conversations with the artist, 1980-81.

5

Alec Bristow, *The Sex Life of Plants*, New York: Holt, Rinehart and Winston, 1978, p. vii. Simonds has a copy of this book which he has annotated.

6

A beautifully presented discussion of the subject is *The Sense of Unity: The Sufi Tradition in Persian Architecture*, by Nader Ardalan and Laleh Bakhtiar, Chicago: The University of Chicago Press, 1973. Simonds has a copy, well-worn.

7

The most direct comparison with these dome dwellings is the type of early Pueblo dwellings from c. 300 A.D. designated as "shallow pithouses." Simple domed roofs erected over shallow depressions in the earth, pithouses were succeeded by the circular ritual kivas, which were completely underground but retained the earlier form. See illustrations and text in Patrick Bardou and Varoujan Arzoumanian, *Archi de Terre*, Paris: Parenthèses (éditions), 1978, p. 36. This contains a discussion of the various materials according to availability and sees earth bricks (unlike tamped earth) as based on the model of stone blocks, the geometry of both allowing a regular, rectangular architecture to evolve. See also Joseph Rykwert, *On Adam's House in Paradise, the Idea of the Primitive Hut in Architectural History*, New York: The Museum of Modern Art, 1972.

8

Probably the first extensive and systematic elaboration of colored clays as metaphors for the assimilation of various geographical regions and indigenous peoples into one culture was the installation of " △ " in "Documenta 6," 1977 (pl. 21). Flatlands (yellow) connoted water and were neuter; hills (pink) were flesh and female; and the mountains (gray) were stone and male. The shapes on top of the triangulated structures (to the left of the three sluices used to direct water to the making of the colored bricks) symbolize the three ingredients as well as their corollary in nature, man, and architecture respectively. Green, red, and gray are used in similar fashion in the two-part work " △ " Early, " △ " Later, 1977 (Walker Art Center, Minneapolis). It should be clarified that there is not a "Triangular People" to add to the Linear, Circular, and Spiral Peoples. Rather, it is a question of setting up the works in a triangular structure, looking down at the intersection of the three parts, a way of mixing the ingredients. As Simonds explained, it is "really a triangular me" (conversation with the artist, August 1981).

9

The *Circles and Towers Growing* have a general schema for installation which nevertheless is adjusted according to the proportions of the exhibition room. Separated by 7-to-8-foot intervals or more, the cycle invites free circulation among the individual works. At one point Simonds had considered showing the works abutting one another, almost as frames on a strip of film. He discarded this idea because it discouraged reading the works in reverse and imposed a closed inevitability on what he saw as a potentially unlimited number of moments possible between the 12 original works. From time to time he has also been intrigued with the idea of elaborate "Hollywood" lighting, but has thus far preferred simple angled overhead spotlights in darkened rooms.

10

It should be kept in mind that *Number 6* was made earlier as part of the room-scaled *Picaresque Landscape* and only later incorporated into *Circles and Towers Growing*. In conversation Simonds has explained the disappearance of prominent details from one landscape to the next as the direct result of action by the Little People, not simple weathering.

11

The passage from one state to another—profane to sacred—through images of an opening, especially openings in the roof, is discussed by Eliade, *The Sacred and The Profane*, pp. 25-26, and in connection with ascension myths in his *Patterns in Comparative Religion*, trans. Rosemary Sheed, New York: Meridian Books, pp. 99 ff.

12

Simonds has made other works dealing with the theme of abandonment: *Abandoned Ritual Workplace*, 1975, and *Abandoned Ritual Place* and *Abandoned Spiral* of 1980. The latter two correspond approximately to the moments of decline manifest in *Circles and Towers Growing*, *Numbers 7, 8*, and *12* (pls. 38, 39, and 43).

13

The quarry, where the earth is measured and cut into blocks to be recombined as buildings, is itself a primary metaphor for the transformation of the landscape at the hands of the Little People. The cutting away creates a repetitive geometry where none existed and on the scale of mountains. In the quarry, however, the emphasis is still more landscape than not. Nor has anything technically been built; rather the landscape is given structure as it is used up. Simonds has built several quarry works, one a simple impromptu exercise soon reworked; the second an elaborate mountainous landscape, one side gray and terraced, the other still oozing red clay from fissures in the "rock." Exhibited as part of a larger installation at the Whitney Biennial Exhibition in 1977 and shown separately later that year at the Walker Art Center in Minneapolis, this portable *Quarry* was subsequently destroyed in an accident. Other quarries can be found in Simonds's large installations, notably the *Picaresque Landscape* (cover ill., though not visible in this detail). Simonds also included a brick-making oven in another portable work, also now destroyed. As man-made equivalents to stone, bricks are nevertheless made of earth and therefore "softer," more organic and "human" than rock. In some of his earliest dwellings, around 1970-71, Simonds made small rolled, rounded bricks

containing seeds which anticipated the full-scale *Growth House* of 1975 (see pl. 28). Another work was made with similar bricks mixed with his own blood. For illustrations of the early works (which have a very different feeling from the later ones constructed from cut bricks), see Bib. I 1975, Simonds and Abadie, pp. 57, 59.

14
A listing of similar dualities of gender in buildings is proposed by Margrit Kennedy, "Seven Hypotheses on Female and Male Principles in Architecture," *Heresies 11*, 3, 3 (1981) pp. 12-13.

All works comprising *Circles and Towers Growing* are made of clay on a plywood base with sand, pebbles, sticks, bones, and shells. The dimensions are approximately 76.2 x 76.2 cm (30 x 30 in.) with variable heights.

*Plate 32. *Number 1 (Untitled)*, 1978. Collection of the artist.

*Plate 33. *Number 2 (Untitled)*, 1978. Collection of the artist.

*Plate 34. *Number 3 (Untitled)*, 1978. Private Collection, Paris.

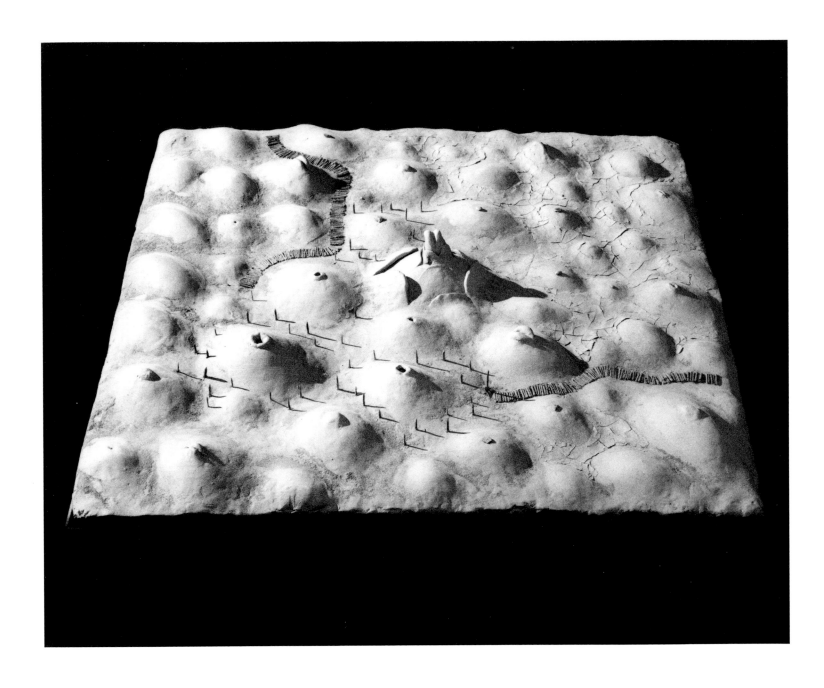

*Plate 35. *Number 4 (Untitled)*, 1978. Collection of the artist.

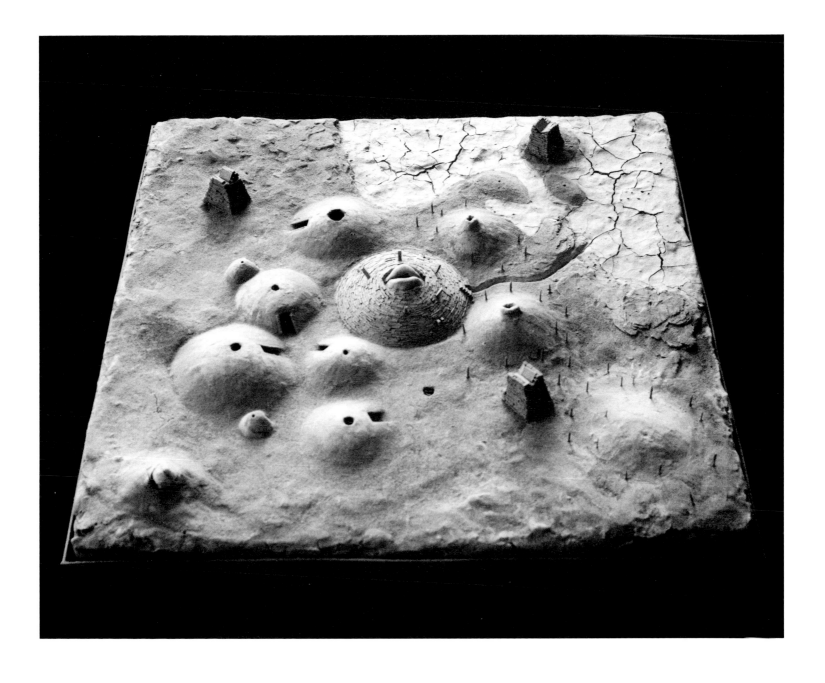

*Plate 36. *Number 5 (Observatory)*, 1978. Collection of the artist.

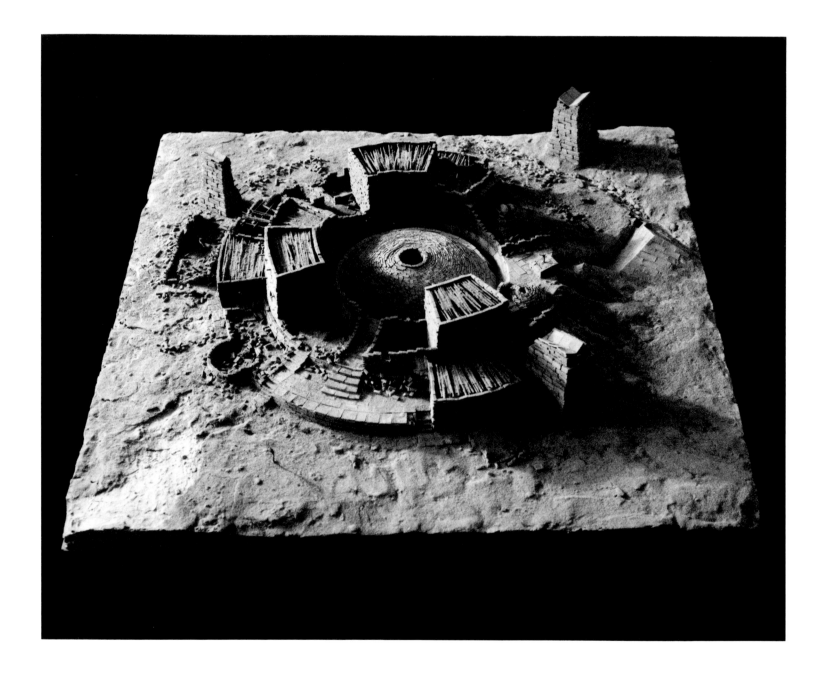

*Plate 37. *Number 6 (Untitled),* 1978. Collection of the artist.

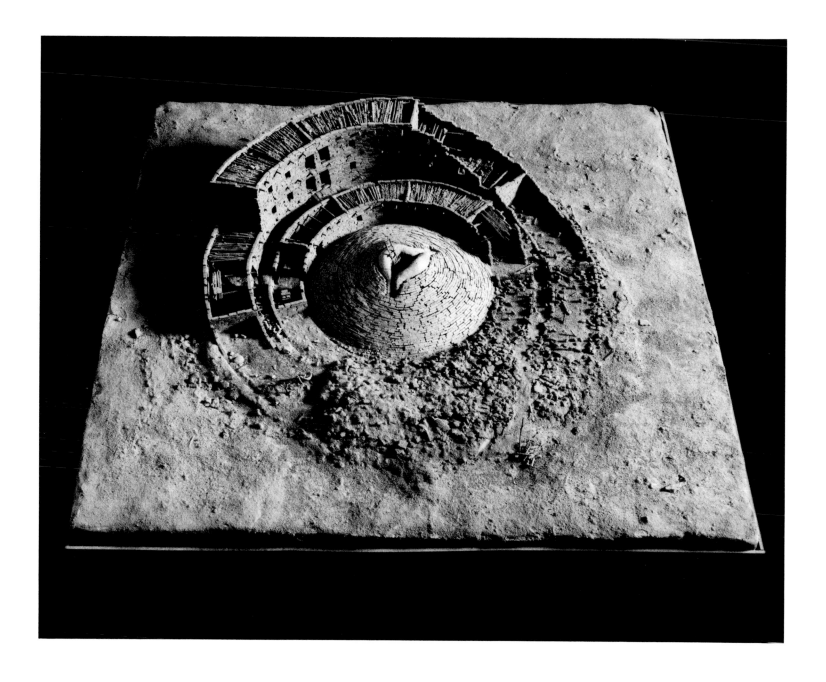

*Plate 38. *Number 7 (Untitled)*, 1978. Collection of the artist.

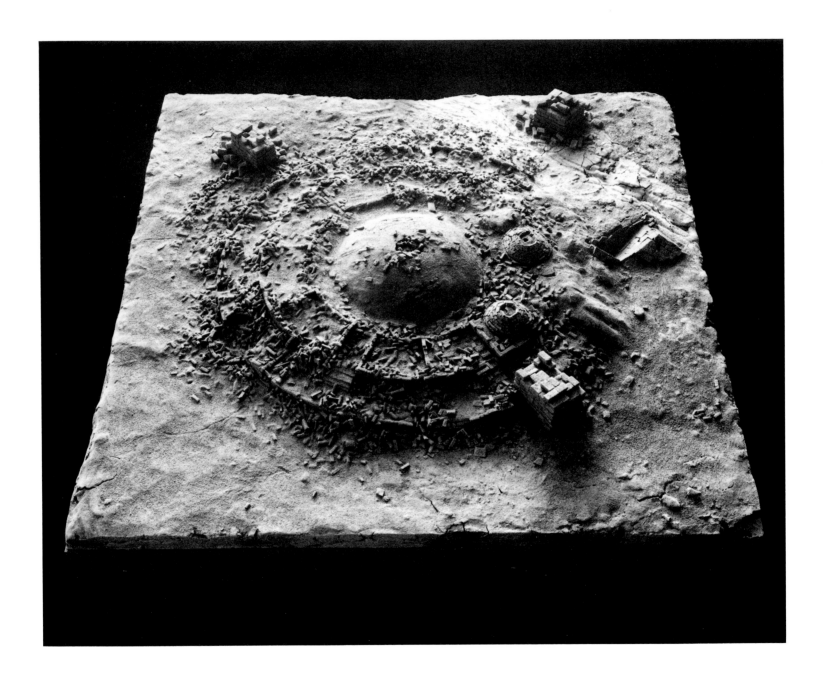

*Plate 39. *Number 8 (Untitled)*, 1978. Collection of the artist.

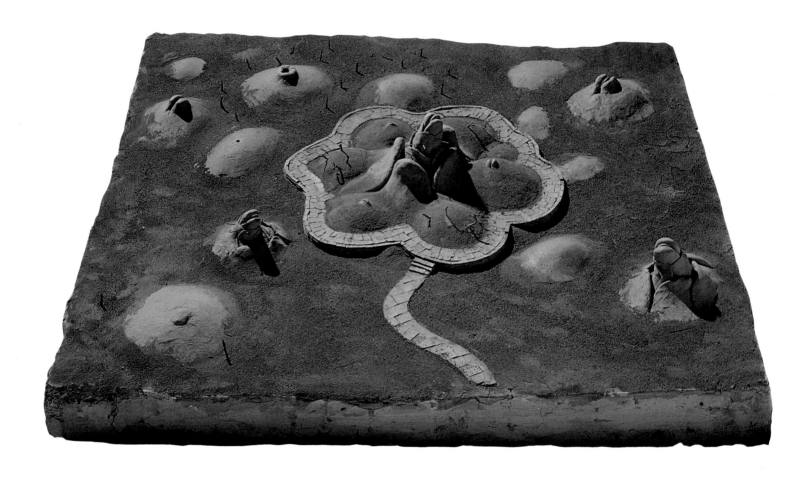

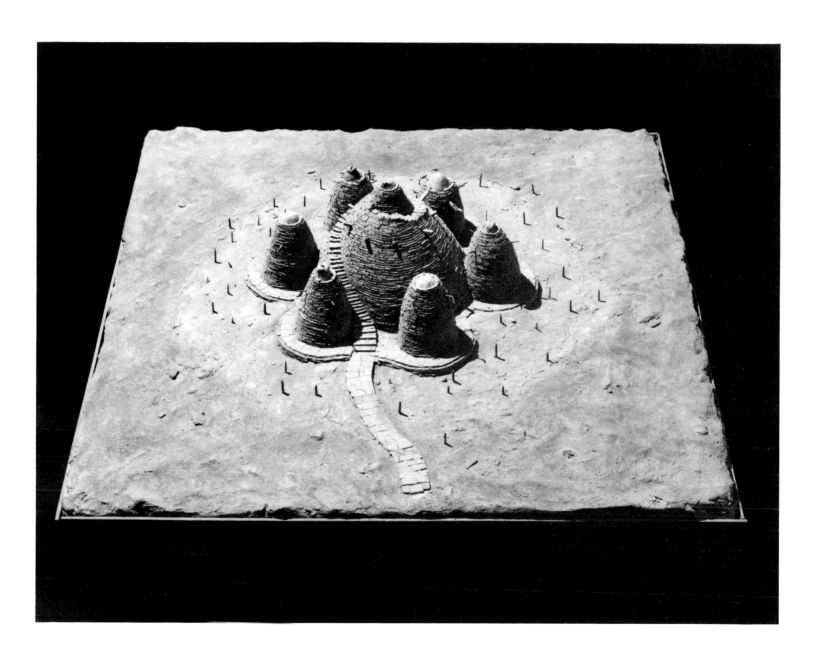

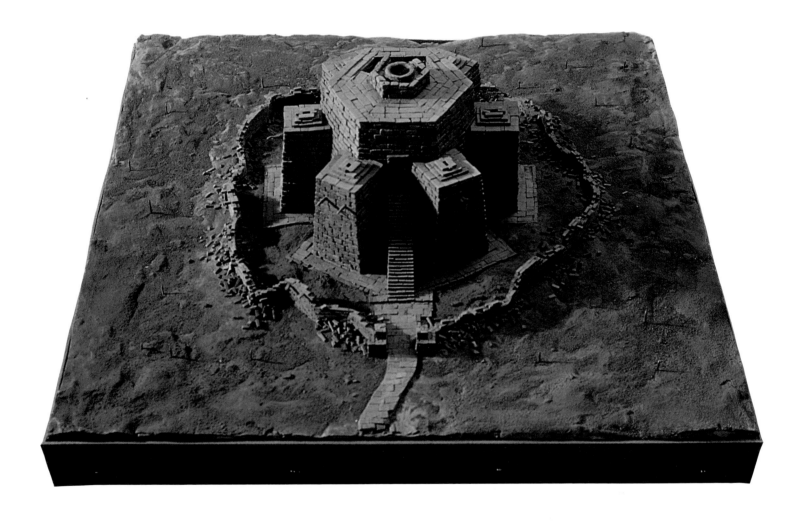

*Plate 43. *Number 12 (Untitled)*, 1978. Collection of the artist.

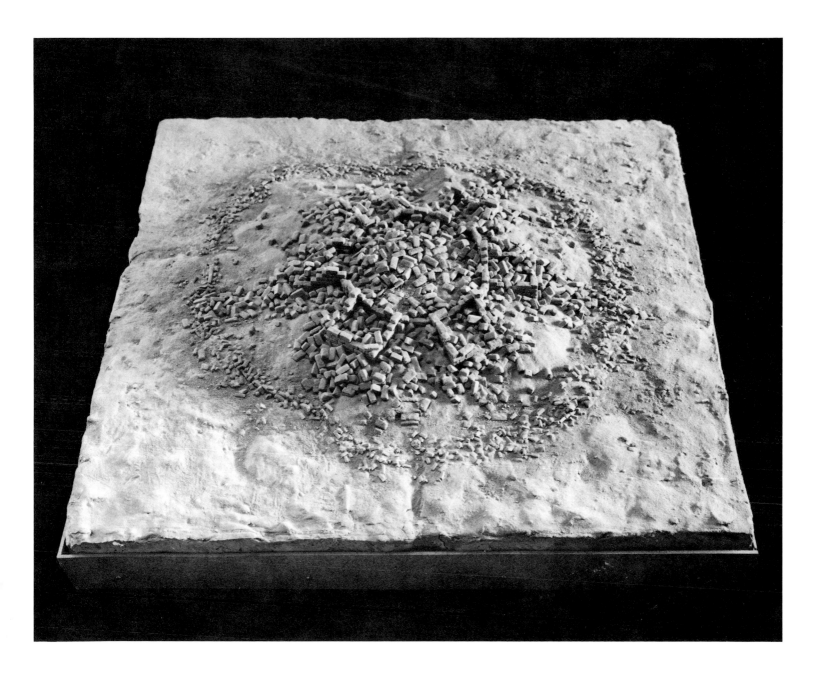

House Plants

This recent sequence is comprised of three pieces—fantasies about the formal and functional analogies between the body, plants, and the built. They are mixed metaphors for evolution.

*Plate 44. *Ground Bud*, 1981. Collection of the artist.

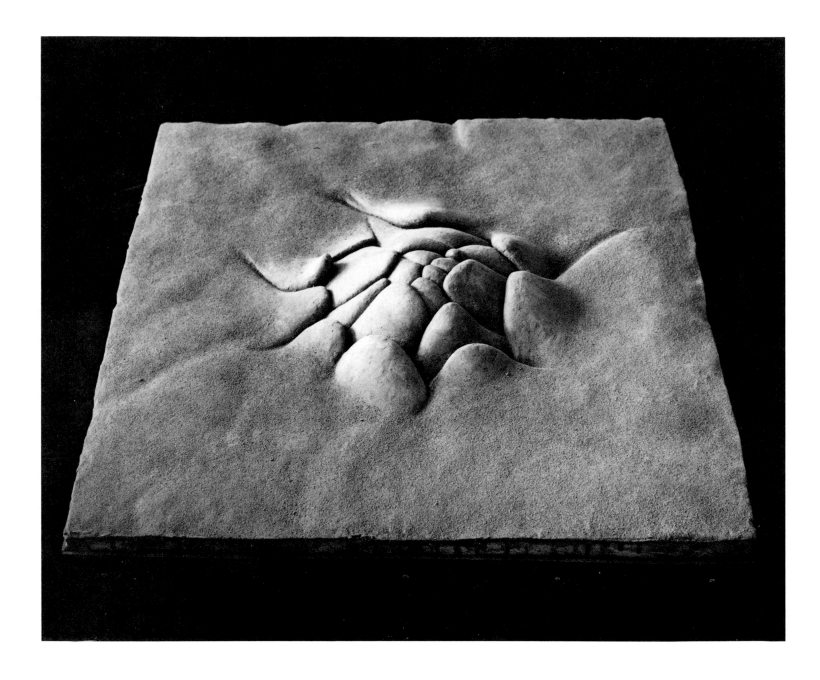

*Plate 45. *Stone Sprout,* 1981. Collection of the artist.

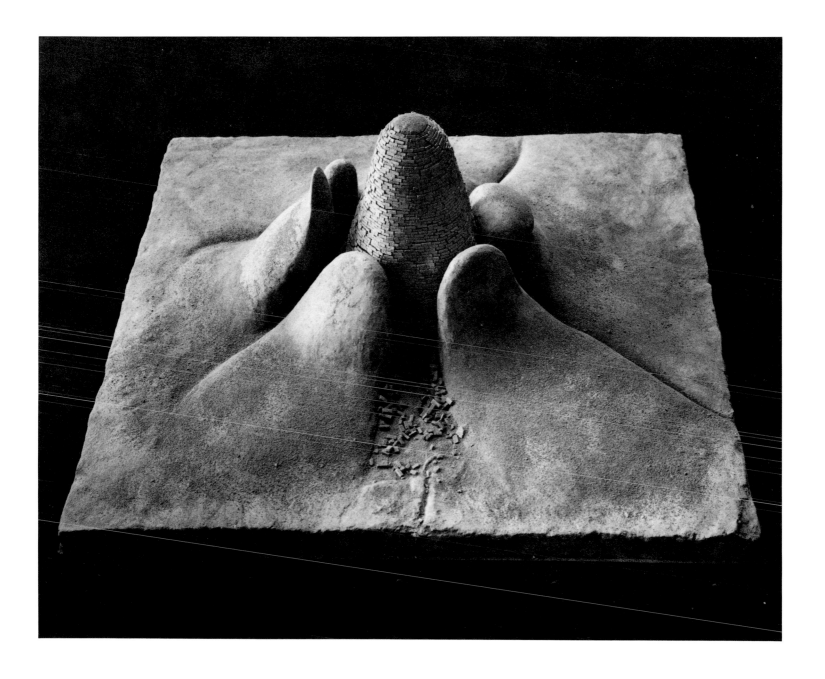

*Plate 46. *Brick Blossom*, 1981. Collection of the artist.

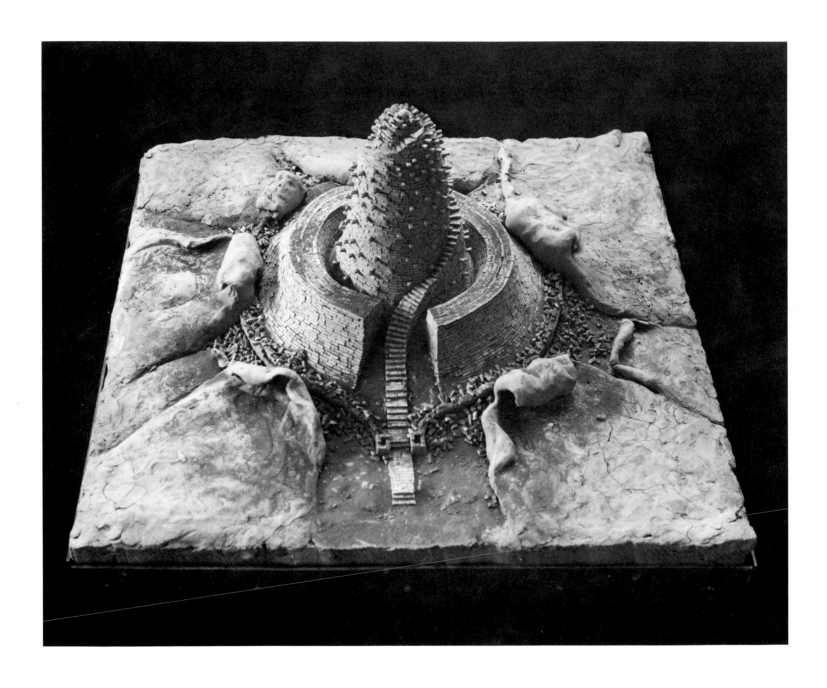

One-Person Exhibitions

1975-76
Centre National d'Art et de Culture Georges Pompidou, Paris, "Charles Simonds: Demeures et Mythologies" (exh. cat.)
Samangallery, Genoa, Italy

1976
Museum of Modern Art, New York, "Projects: Charles Simonds: Picaresque Landscape" (also traveled to New York Public Library, Tompkins Square)

1977
Albright-Knox Art Gallery, Buffalo, New York, "Charles Simonds: Temenos" (exh. cat.)

1978
Westfälischer Kunstverein, Münster, West Germany and Bonner Kunstverein, Bonn, "Charles Simonds: Floating Cities and Other Architectures," organized with the help of the Berliner Künstlerprogramm des Deutschen Akademischen Austauschdienstes (DAAD) (exh. cat.)

1979
Wallraf-Richartz Museum, Museum Ludwig, Cologne; Nationalgalerie, Berlin; Musée de l'Abbaye Sainte-Croix, Les Sables–d'Olonne, France; and Galerie Baudoin Lebon, Paris, "Circles and Towers Growing" (exh. cat.)
Centre d'Art Contemporain, Geneva, Switzerland and Samangallery, Genoa, "Floating Cities"

1980
Beaumont-May Gallery, Dartmouth College, Hanover, New Hampshire
California State University at Los Angeles

Selected Group Exhibitions

1971
112 Greene Street, New York

1972
Willard Gallery, New York

1973
Musée d'Art Moderne de la Ville de Paris, "8e Biennale de Paris" (exh. cat.)

1974
Hayden Gallery, Massachusetts Institute of Technology, Cambridge, "Interventions in Landscape" (exh. cat.)

1975
Whitney Museum of American Art, New York, "1975 Biennial Exhibition: Contemporary American Art" (exh. cat.)
Artists Space, New York
112 Greene Street, New York
Vassar College Art Gallery, Poughkeepsie, New York, "Primitive Presence in the '70's" (exh. cat.)
Musée d'Art Moderne de la Ville de Paris, "9e Biennale de Paris" (exh. cat.)
"Art in Landscape," a traveling exhibition organized by Independent Curators, Inc., Washington, D.C. (exh. cat.; see Bib. II 1975, Washington)
Fine Arts Building, New York, "Not Photography"
Art Institute of Chicago, "Small Scale" (exh. cat.)

1976
Fine Arts Building, New York, "Scale"
Fine Arts Building, New York, "Personal Mythologies"
Musées de Nice, "9e Biennale de Paris à Nice" (exh. cat.)
Philadelphia College of Art, "Projects for PCA" (exh. cat.)
American Museum of Natural History, New York, "Earth Day Festival, 1976"
Venice, "XXXVIIe Biennale di Venezia '76" (exh. cat.)

1977
Whitney Museum of American Art, New York, "1977 Biennial Exhibition: Contemporary American Art" (exh. cat.)
Visual Arts Museum, New York, "A Question of Scale"
The New Gallery of Contemporary Art and Cleveland State University, Ohio, "City Project 1977: Four Urban Environmental Sculptures," organized by Independent Curators, Inc., Washington, D.C. (exh. cat.; see Bib. II 1977, Cleveland)
Walker Art Center, Minneapolis, "Scale and Environment: 10 Sculptors" (exh. cat.)

1977-78

Hirshhorn Museum and Sculpture Garden, Smithsonian Institution, Washington, D.C.; La Jolla Museum of Contemporary Art, California; and Seattle Art Museum, "Probing the Earth: Contemporary Land Projects" (exh. cat.)

Kassel, West Germany, "Documenta 6" (exh. cat.)

Gallery Magers, Bonn, West Germany, "Kunst und Architektur" (exh. cat.)

1978

The American Center, Paris, "Spring Festival," organized by Galerie Baudoin Lebon, Paris (exh. cat.)

Centre d'Arts Plastiques Contemporains de Bordeaux, "Sculpture/Nature" (exh. cat.)

Whitney Museum of American Art, Downtown Branch, New York, "Architectural Analogues" (exh. cat.)

Stedelijk Museum, Amsterdam, "Made by Sculptors" (exh. cat.)

Institute of Contemporary Art, University of Pennsylvania, Philadelphia, "Dwellings" (exh. cat.)

Venice, "XXXVIIIe Biennale di Venezia '78" (exh. cat.)

Wright State University and the City Beautiful Council, Dayton, Ohio, Alternative Spaces Residency Program, "Quintessence" (exh. cat.; see Bib. II 1978, Dayton)

Rosa Esman Gallery, New York

DAADgalerie, Berlin, "DAAD Artists"

1979

Museum of Modern Art, New York, "Contemporary Sculpture: Selections from the Collection of The Museum of Modern Art" (exh. cat.)

Neuberger Museum, State University of New York at Purchase, "Ten Artists/Artists Space" (exh. cat.)

1979-80

"Supershow," a traveling exhibition organized by Independent Curators, Inc., New York (exh. cat.; see Bib. II 1979, New York)

Institute of Contemporary Art, University of Pennsylvania, Philadelphia, "Masks, Tents, Vessels, Talismans" (exh. cat.)

1980

Vancouver Art Gallery, British Columbia, "Architectural References" (exh. cat.)

Hayward Gallery, London and Rijksmuseum Kröller-Müller, Otterlo, The Netherlands, "Pier + Ocean: Construction in the Art of the Seventies" (exh. cat.)

National Gallery of Ireland, Dublin and the School of Architecture in University College, Dublin, "ROSC—'80" (exh. cat.)

Washington, D.C., "Eleventh International Sculpture Conference"

California State University at Los Angeles, "Charles Simonds" (exh. cat.); from "Architectural Sculpture," an exhibition organized by the Los Angeles Institute of Contemporary Art (exh. cat.)

1981

Rosa Esman Gallery, New York, "Architecture by Artists"

Kunsthaus Zürich, "Mythos & Ritual in der Kunst der 70er Jahre"

Commissions, Projects, Films

Public Collections

Commissions

1974
Artpark, Lewiston, New York, *Excavated and Inhabited Railroad Tunnel Remains and Ritual Cairns, Niagara Gorge*

1975
Artpark, Lewiston, New York, *Growth House*

1980
Private Collection, Antwerp, Belgium (permanent installation)

1981
Lannon Foundation, Palm Beach, Florida, *Range* (permanent installation)
Whitney Museum of American Art, New York (permanent installation)
Kunsthaus Zürich (permanent installation)
Museum of Contemporary Art, Chicago (permanent installation)

Projects

1970-76
New York, Lower East Side Project
East 2nd Street, New York, Project Uphill-La Placita (a park/playlot/sculpture constructed in cooperation with the Lower East Side Coalition for Human Housing, the Association of Community Service Centers, and the Young New Yorkers)

1977
Cleveland, Ohio, City Project

Films (16 mm)

1977
Birth (filmed and edited by Charles Simonds; color, 2 min.)

1972
Dwellings (filmed and edited by David Troy; black and white, 11 min.)

1973
Landscape ⸺ Body ⸺ Dwelling (filmed by Rudolph Burckhardt, edited by Charles Simonds; color, 7 min.)

1974
Body ⸺ Earth (filmed by Rudolph Burckhardt, edited by Charles Simonds; color, 3 min.)
Dwellings Winter 1974 (filmed and edited by Rudolph Burckhardt; color, 13 min.)
Niagara Gorge (filmed by Emil Antonucci, edited by Charles Simonds; color, 10 min.)

Allen Memorial Art Museum, Oberlin College, Oberlin, Ohio
Art Gallery of South Australia, Adelaide
Centre National d'Art et de Culture Georges Pompidou, Paris
Israel Museum, Jerusalem
Kunsthaus Zürich, Switzerland
Lannon Foundation, Palm Beach, Florida
Museum of Contemporary Art, Chicago
Wallraf-Richartz Museum, Museum Ludwig, Cologne
Museum of Modern Art, New York
Storm King Art Center, New York
Walker Art Center, Minneapolis
Whitney Museum of American Art, New York

Selected Bibliography

I. *Publications by and interviews with the artist, arranged chronologically.*

Simonds, Charles. "Miniature Dwelling." *On Site* 4 (1973).

Simonds, Charles, and Lippard, Lucy. "Microcosm to Macrocosm/Fantasy World to Real World." *Artforum* 12, 6 (February 1974), pp. 36-39.

Simonds, Charles. "Letter to the Editor." *Artforum* 12, 9 (May 1974), p. 9.

Simonds, Charles. *Three Peoples.* Genoa: Samanedizione, 1975. Reprinted in Bib. I 1978, Simonds and Molderings; Bib. II: 1976, Stone and Sky; 1977, Sondheim; 1978, Apel; 1978, Deecke.

Simonds, Charles, and Abadie, Daniel. *Art/Cahier 2.* Paris: SMI 1975.

Simonds, Charles, and Molderings, Herbert. *Charles Simonds: Schwebende Städte und andere Architekturen/Floating Cities and Other Architectures.* Münster: Westfälischer Kunstverein, 1978 (exh. cat.).

Simonds, Charles, and Pohlen, Annelie. "Interview mit Charles Simonds." *Heute Kunst/Flash Art* 24 (January-February 1979), pp. 16-17.

Simonds, Charles. "Working in the Streets of Shanghai and Guilin." *Artforum* 16, 10 (Summer 1960), pp. 60-61.

II. *Publications about the artist; exhibition catalogues listed chronologically at the end of each year.*

1973
Abadie, Daniel, and Néret, Gilles. "Le Deuxième Souffle de la Biennale de Paris." *L'Oeil* 219 (October 1973), p. 49.

Paris, Musée d'Art Moderne de la Ville de Paris. *8ᵉ Biennale de Paris.* Paris: 1973 (exh. cat.).

1974
Larson, Kay." 'Interventions in Landscape': Earth Art at M.I.T." *The Free Paper* (Boston), May 1, 1974, pp. 24-25.

"Vernacular Myth." *Art Rite* 6 (Summer 1974), pp. 9-11.

Reeves, Jean. "New-Breed Artist Seeking Awareness." *Buffalo Evening News,* July 20, 1974.

"Sculpture: Artpark, 1974." *Artscanada* 31, 190-191 (Autumn 1974), pp. 92-93.

Cambridge, Massachusetts. Hayden Gallery, Massachusetts Institute of Technology. *Interventions in Landscape.* Cambridge: 1974 (exh. cat.).

1975
Moore, Alan. "Review: Charles Simonds at Artists Space and 112 Greene Street." *Artforum* 13, 7 (March 1975), p. 72 (ill.).

Saman (Genoa) 1 (March-April 1975); 2 (May-June 1975); 3 (October-November 1975); 4 (December 1975-January 1976); 7 (October-November 1976); 8 (January-February 1977); 14 (October-November 1978).

Markoutsas, Elaine. "A Frank Lloyd Wright of Lilliputian dwellings." *Chicago Tribune,* May 12, 1975, p. 3:19.

Mayer, Rosemary. "Charles Simonds at Artists Space." *Art in America* 63, 3 (May-June 1975), pp. 91-92.

McConathy, Dale. "Keeping Time: Some Notes on Reinhardt, Smithson & Simonds." *Artscanada* 32, 198-199 (June 1975), pp. 52-57.

Abadie, Daniel. "Charles Simonds." +, −, o 10 (September 1975), p. 21.

Huser, France. "De New York à Ménilmontant: Demeures et Mythologies de Charles Simonds." *Le Nouvel Observateur,* November 24, 1975, p. 84.

Leveque, Jean-Jacques. "Deux Sorciers du temps présent." *Le Quotidien de Paris,* November 24, 1975.

Leveque, Jean-Jacques, and Verlomme, Hugo. "Une Reflexion sur un avenir possible: Charles Simonds." *Les Nouvelles Littéraires,* November 24-30, 1975.

Ratcliffe, Carter. "On Contemporary Primitivism." *Artforum* 14, 3 (November 1975), pp. 57-65, esp. 61-62 (ill.).

Schneider, Pierre. "Les Lilliputiens de Simonds." *L'Express,* December 8-14, 1975, p. 35.

Saulnier, Emmanuel. "Des Lutins dans la ville." *Libération,* December 9, 1975.

Wolfin, Marie-Claude. "Une Mystique sexuelle." *Info Artitudes* 3 (December 1975), p. 4.

New York. Whitney Museum of American Art. *1975 Biennial Exhibition: Contemporary American Art.* New York: 1975 (exh. cat.).

Poughkeepsie, New York. Vassar College Art Gallery. *Primitive Presence in the '70's.* Poughkeepsie: 1975 (exh. cat.).

Paris. Musée d'Art Moderne de la Ville de Paris. *9ᵉ Biennale de Paris.* Paris: 1975 (exh. cat.).

Washington, D.C. Independent Curators, Inc. *Art in Landscape.* Curated by Susan Sollins. Washington: 1975 (exh. cat. for traveling exhibition).

Art Institute of Chicago. *Small Scale.* Chicago: 1975 (exh. cat.).

1976
Metken, Günter. "Charles Simonds." *Süddeutsche Zeitung,* January 21, 1976.

Leenhardt, Jacques. "L'Urbanisme parallèle de Charles Simonds." *Journal de Genève,* January 31, 1976; and *La Gazette de Lausanne,* January 31, 1976.

Restany, Pierre, "Little People: Omuncoli, Les Demeures de Charles Simonds pour un peuple imaginaire." *Domus* 555 (February 1976), pp. 52-53.

Celant, Germano. "Charles Simonds: Little People." *Casabella* 411 (March 1976), pp. 39-42.

Russell, John. "Charles Simonds' Little People." *New York Times,* June 20, 1976, p. 41.

Foote, Nancy. "The Apotheosis of the Crummy Space." *Artforum* 15, 2 (October 1976), pp. 28-37 (ill.).

Hess, Thomas B. "This and That Side of Paradise." *New York Magazine,* November 22, 1976, pp. 104-105.

Jonas, Gerald. "The Little People." *The New Yorker* 52, 40, November 22, 1976, pp. 38-40.

Lascault, Gilbert. "Villes Miniaturisées." *XXᵉ Siècle* 38, 47 (December 1976), pp. 131-135.

Stone, Michelle, and Sky, Allison, eds. *Unbuilt America.* New York: McGraw Hill, 1976.

Nice, France. Musées de Nice. *9ᵉ Biennale de Paris à Nice.* Nice: 1976 (exh. cat.).

Philadelphia College of Art. *Projects for PCA: Anne Healy, Patrick Ireland, Robert Irwin, Charles Simonds.* Text by Janet Kardon. Philadelphia: 1976 (exh. cat.).

Venice, Italy. *La Biennale di Venezia '76, II, Section of Visual Art and Architecture.* "International Events '72-76." Venice: 1976 (exh. cat.).

Lewiston, New York. *Artpark 1974.* Lewiston: 1976 (exh. cat.).

1977
Baracks, Barbara. "Review: Charles Simonds and Mary Miss, Museum of Modern Art. . . ." *Artforum* 15, 5 (January 1977), pp. 57-58.

Zucker, Barbara. "Review: Museum of Modern Art." *Art News* 76, 1 (January 1977), p. 124.

Wallach, Amei. "Once Again It's Potpourri Time at the Whitney." *The Arts,* February 27, 1977, p. 11-15.

Russell, John. "Intimations of Catastrophe." *New York Times,* March 20, 1977.

Lippard, Lucy. "Art Outdoors, In and Out of the Public Domain." *Studio International* 193 (March-April 1977), pp. 83-90.

Forgey, Benjamin. "The Whitney Biennial." *Art News* 76, 4 (April 1977), p. 120 (ill.).

Sischy, Ingrid. "Review of Individuals." *Print Collectors Newsletter* 8, 2 (May-June 1977), p. 47.

S., C. "Gebaute Miniaturen: Charles Simonds' Wohnlandschaften der 'kleinen Leute.' " *Kultur* 146, June 28, 1977.

Herrera, Hayden. "Manhattan Seven." *Art in America* 65, 4 (July-August 1977), pp. 57-59.

Hohmeyer, Jürgen. "Charles Simonds' 'Kleine Leute' in Kreuzberg." *Der Spiegel,* November 21, 1977, pp. 228-233.

Sondheim, Alan, ed. *Individuals: Post-Movement Art in America.* New York: E. P. Dutton and Co., 1977.

New York. Whitney Museum of American Art. *1977 Biennial Exhibition: Contemporary American Art.* New York: 1977 (exh. cat.).

Cleveland, Ohio. The New Gallery of Contemporary Art, Cleveland, and Cleveland State University Art Department. *City Project 1977: Four Urban Environmental Sculptures.* Cleveland: 1977 (exh. cat.).

Minneapolis, Minnesota. Walker Art Center. *Scale and Environment: 10 Sculptors.* Simonds essay by Lisa Lyons. Minneapolis: 1977 (exh. cat.).

Washington, D.C. Hirshhorn Museum and Sculpture Garden, Smithsonian Institution. *Probing the Earth: Contemporary Land Projects.* Text by John Beardsley. Washington: 1977 (exh. cat.).

Kassel, West Germany. *Documenta 6.* Kassel: 1977 (exh. cat.).

Bonn. Gallery Magers. *Kunst und Architektur.* Bonn: 1977 (exh. cat.).

Buffalo, New York. Buffalo Fine Arts Academy and the Albright-Knox Art Gallery. *Charles Simonds.* Buffalo: 1977 (exh. cat. for Albright-Knox exh.).

1978
McWilliams Wright, Martha. "Review: Probing the Earth: Contemporary Land Projects—Hirshhorn Museum and Sculpture Garden." *Art International* 22 (January 1978), p. 63 (ill.).

Hegemann, William R. "Scale & Environment: Walker Art Center, Minneapolis; exhibit." *Art News* 77, 1 (January 1978), p. 116.

Knight, C. "Some recent art and an architectural analogue." *LAICA Journal* 17 (January-February 1978), pp. 50-54.

Hasenkamp, Joh(annes?). "Ursprüngliches und Futurismen: Der Westfälische Kunstverein zeigt Arbeiten von Nikolaus Lang und Charles Simonds." *Westfälische Nachrichten*, March 11, 1978.

Lober, Hermann. "Von Zukunft und Ursprung: Nikolaus Lang, Charles Simonds in Münsters Kunstverein." *Münstersche Zeitung*, March 22, 1978.

Haase, Amine. "Auf den Spuren versunkener Zeit: Charles Simonds, Nikolaus Lang und Urs Lüthi in Münster und Essen." *Rheinische Post*, March 29, 1978.

Jochimsen, Margarethe. "Kunst als soziale Strategie." *Kunstforum International* 27 (March 1978), pp. 72-99.

Pohlen, Annelie. "Eine Utopie, die herausfordert: Simonds 'Strassenwelten' im Städtischen Kunstmuseum." *Bonner Stadtanzeiger*, April 19, 1978.

Gosch, Brigitte. "Strassenkünstler aus Amerika: Kunstspiel mit Kindern—Front gegen Musentempel." *Westfälischer Rundschen*, April 20, 1978.

Winter, Peter. "Nistplätze für die Phantasie der Stadtbewohner: Charles Simonds in Bonn." *Frankfurter Allgemeine Zeitung*, April 26, 1978.

Pohlen, Anneliese. "Ausbruch auf die Strasse: Die kleinen Welten von Charles Simonds in Bonn." *Kultur* 20, May 18, 1978, p. 25.

Lipper, Hal. "Seen any Little People? Tell them their homes are ready." *Dayton Daily News* (Ohio), May 24, 1978, pp. 1, 6.

Beardsley, John. "Robert Smithson and the Dialectical Landscape." *Arts Magazine* 52, 9 (May 1978), pp. 134-135.

Winter, Peter. "Erde ist der Urbaustoff des Menschen." *du-journal* (May 1978), p. 14.

Apel, Friedmar. "Der Baumeister der Träume: Wirklichkeit und Gedankenspiel bei Charles Simonds." *Sprache im Technischen Zeitalter* 6 (July 1978).

Alinovi, Francesca. "Grande, grandissimo. Piccolo, piccolissimo. L'Arte di Gulliver." *Bolaffiarte* 9, 82 (September-October 1978), pp. 41ff.

Winter, Peter. "Schwebende Städte und andere Architekturen: Städtisches Kunstmuseum, Bonn; Ausstellung." *Pantheon* 36 (October 1978), pp. 357-358 (ill.).

Saulnier, Emmanuel. "Charles Simonds: Habiter New York." *Opus International* 65 (Paris) (Winter 1978), pp. 31-33.

Deecke, Thomas. "Die Ruinenlandschaften Charles Simonds—Architektonische Phantasie." *Kunstmagazin* 82 (1978), pp. 62-70, cover.

Paris. The American Center. *Spring Festival 1978*. Paris: 1978 (exh. cat.; organized by Galerie Baudoin Lebon, Paris).

Bordeaux, France. Centre d'Arts Plastiques Contemporains de Bordeaux (CAPC). *Sculpture/Nature*. Bordeaux: 1978 (exh. cat.).

Amsterdam. Stedelijk Museum. *Made by Sculptors*. Amsterdam: 1978 (exh. cat.).

New York. Whitney Museum of American Art, Downtown Branch. *Architectural Analogues*. New York: 1978 (exh. cat.).

Philadelphia. Institute of Contemporary Art, University of Pennsylvania. *Dwellings*. Text by Janet Kardon. Philadelphia: 1978 (exh. cat.).

Venice, Italy. *La Biennale di Venezia '78, Section of Visual Art and Architecture*. "Natura/antinatura." Venice: 1978 (exh. cat.).

Dayton, Ohio. The Alternative Spaces Residency Program administered by the City Beautiful Council and the Wright State University. *Quintessence*. Dayton: 1978 (exh. cat.).

1979
Beardsley, John. "Charles Simonds: Extending the Metaphor." *Art International* 22, 9 (February 1979), pp. 14-19, 34.

Stevens, Mark. "The Dizzy Decade." *Newsweek* 93, 13, March 26, 1979, pp. 88-94.

Linker, Kate. "Charles Simonds' Emblematic Architecture." *Artforum* 17, 7 (March 1979), pp. 32-37.

"Utopie im Liliput-Format: Charles Simonds in der Neuen Nationalgalerie." *Der Tagesspiegel*, May 4, 1979, p. 5.

Schmidt, Philip Peter. "Zurück zur Natur: Bau-Arbeiten: George [sic] Simonds in de Nationalgalerie." *Der Abend*, May 7, 1979.

Russell, John. "Art: 'Contemporary Sculpture' at Modern." *New York Times*, June 15, 1979.

Lascault, Gilbert. "Apprendre à habiter." *La Quinzaine Littéraire* 307, August 31, 1979.

Daval, Jean-Luc. *Skira Annuel N° 5: Art Actuel '79*. Geneva: Editions Skira S.A., 1979, pp. 112-113, 155.

Lippard, Lucy. *Cracking*. Cologne: Walter König, 1979 (a book done in conjunction with the "Circles and Towers Growing" exhibitions in Cologne and Berlin).

Köln. Museen der Stadt. *Handbuch Museum Ludwig*. Köln: 1979, pp. 738-740 (ill.), 857.

"Traumlöcher und Traditionen." *Tip Magazin* 10 (1979), pp. 36-37.

New York. Museum of Modern Art. *Contemporary Sculpture. Selections from the Collection of the Museum of Modern Art.* New York: 1979 (exh. cat.).

Purchase, New York. Neuberger Museum, State University of New York College at Purchase. *Ten Artists/Artists Space.* Essay by Helene Winer. Purchase: 1979 (exh. cat.).

New York. Independent Curators, Inc. *Supershow.* Curated by Susan Sollins and Elke Solomon. New York: 1979 (exh. cat. for traveling exhibition).

Philadelphia. Institute of Contemporary Art, University of Pennsylvania. *Masks, Tents, Vessels, Talismans.* Text by Janet Kardon. Philadelphia: 1979 (exh. cat.).

Les Sables-d'Olonne, France. Musée de l'Abbaye Sainte-Croix. *Charles Simonds: "Evolution imaginaire d'un paysage."* Text by Gilbert Lascault. Les Sables-d'Olonne: Cahiers de l'Abbaye Sainte-Croix, 1979 (exh. cat.).

1980
Gibson, Michael. "Baudoin Lebon Gallery, Paris; exhibit." *Art News* 79, 1 (January 1980), pp. 121-122.

Foote, Nancy. "Situation Esthetics: Impermanent Art and the Seventies Audience." *Artforum* 18, 5 (January 1980), p. 29.

Linker, Kate. "An Anti-Architectural Analogue." *Flash Art* 94 (January-February 1980), pp. 20-25.

Hjort, Øystein. "Mot en ny sensibilitet: Några tendenser i ny amerikansk konst." *Paletten* 2 (1980), pp. 35-36.

"Observatoire abandonné (1976)." *Architecture d'Aujourd'hui* 208 (April 1980), p. liv.

Cork, Richard. "Little People live here." *Evening Standard* (London), May 28, 1980, p. 21.

Shapiro, Babs. "Architectural References: The Consequences of the Post-Modern in Contemporary Art and Architecture." *Vanguard* 9, 4 (May 1980), pp. 6-13.

"People who live in a circle (1976)." *Art and Artists* 15 (July 1980), p. 27.

Forgey, Benjamin. "It takes more than an outdoor site to make sculpture public." *Art News* 79, 7 (September 1980) pp. 84-88 (ill.).

Clothier, Peter. "Charles Simonds: Architecture Humanized." *Artweek* 11, 35, October 25, 1980, pp. 1-2.

Restany, Pierre. "L'Immagine del Nostro Destino." *Domus* 610 (October 1980), pp. 2-7.

Daval, Jean-Luc. *Skira Annuel N° 6: Art Actuel—Numéro Spécial 1970-1980.* Geneva: Editions Skira S.A., 1980, pp. 121, 160.

Vancouver Art Gallery. *Architectural References.* Vancouver: 1980 (exh. cat.).

London, Hayward Gallery, and Otterlo, Rijksmuseum Kröller-Müller. *Pier + Ocean: Construction in the Art of the Seventies.* Exhibition selected by Gerhard von Graevenitz assisted by Norman Dilworth. London: 1980 (exh. cat.).

Dublin. National Gallery of Ireland and School of Architecture in University College. *ROSC.* Dublin: 1980 (exh. cat.).

Los Angeles Institute of Contemporary Art. *Architectural Sculpture.* Los Angeles: 1980 (exh. cat.).

1981
Francblin, Catherine. "Charles Simonds bâtisseur de ruines." *Art Press* 45 (February 1981), pp. 14-15.

Mr. & Mrs. Thomas S. Farmer
Mr. & Mrs. Merton Feldstein
Mr. & Mrs. Milton L. Fisher
Mrs. Walter T. Fisher
Elaine & Willard Freehling
Mr. Marshall Frankel
Michael R. & Jill M. Friedberg
Mr. & Mrs. Oscar L. Gerber
Mr. & Mrs. Oscar Getz
Mr. & Mrs. Gerald Gidwitz
Mr. Joseph L. Gidwitz
Barbara & Erwin Glass
Donald & Maureen Glassberg
Mr. & Mrs. Edward R. Glick
Mr. & Mrs. Ralph I. Goldenberg
Mr. & Mrs. Marvin Gottlieb
Mr. & Mrs. Paul Gotskind
Mr. & Mrs. Bruce J. Graham
Richard & Mary L. Gray
Mr. Leo S. Guthman
Mr. & Mrs. Albert F. Haas
Mr. & Mrs. Robert F. Hanson
Mr. & Mrs. Allan Harris
Mr. & Mrs. King Harris
Mrs. Rosetta W. Harris
Mr. & Mrs. Richard F. Hart
Mr. & Mrs. Robert S. Hartman
Mr. & Mrs. Jerome Hasterlik
Nancy W. Hillman
Mr. & Mrs. Howard D. Hirsch
Dr. & Mrs. Jerome H. Hirschmann
Mr. & Mrs. James Hoge
Mr. & Mrs. Edwin E. Hokin
Mr. Myron Hokin
Mr. William J. Hokin
Carol & Joel Honigberg
Mr. & Mrs. Franklin E. Horwich
Mr. & Mrs. Herbert Horwich

Mr. & Mrs. Hal Iyengar
Dr. & Mrs. James E. Jones
Mr. David Joyce
Ruth & David V. Kahn
Mr. Burton W. Kanter
Mr. & Mrs. Bernard Kaplan
Mrs. Harvey Kaplan
Roberta & Joel Kaplan
Mr. & Mrs. George P. Kelly
Mr. & Mrs. John C. Kern
Mrs. Meyer Kestnbaum
Mr. & Mrs. Samuel W. Koffler
Sherry & Alan Koppel
Mr. & Mrs. Daniel Levin
Mr. & Mrs. Julius Y. Levinson
Mr. & Mrs. Arthur Levoff
Mrs. Henry R. Levy
Mr. Robert A. Lewis
Mr. & Mrs. Richard Lieberman
Mr. & Mrs. Bruce A. Littman
Mr. & Mrs. Albert Lockett
Dr. & Mrs. Arthur Loewy
Mrs. Renee Logan
Reva and David Logan Foundation
Donald & Amy Lubin
Mr. & Mrs. Lewis Manilow
Mr. & Mrs. Herbert Manning
Marshall Field & Company/
Angelo R. Arena, President
Mr. Arnold A. Martin
Mrs. Robert B. Mayer
Mr. & Mrs. Brooks McCormick
Mrs. Durham Mead
Mr. & Mrs. Theodore N. Miller
Mr. & Mrs. Bernard A. Mitchell
Mr. & Mrs. Bernard Nath
Mr. & Mrs. Joseph E. Nathan
Gael Neeson & Stefan Edlis

Mr. & Mrs. Edward Neisser
Mr. & Mrs. Joel G. Needlman
Arnold & Doris Newberger
Mr. & Mrs. Kenneth Newberger
Albert & Muriel K. Newman
Dr. Edward A. Newman
Mr. & Mrs. Harry Niemiec
Mrs. Murray Nissman
Mr. & Mrs. Paul W. Oliver-Hoffman
Mr. & Mrs. Harry D. Oppenheimer
Mr. & Mrs. J. Michael O'Shaughnessy
Ottawa Silica Company Foundation/
Edmund B. Thornton
Mr. & Mrs. Marshall Padorr
Mrs. Walter Paepcke
Mr. & Mrs. Richard J. Phelan
Mr. & Mrs. Jay Pritzker
Donna K. Rautbord
Dr. & Mrs. William J. Robb III
Mr. & Mrs. Albert A. Robin
Mr. & Mrs. Marvin Romanek
Mr. & Mrs. Robert S. Rosenfels
Mr. & Mrs. Andrew W. Rosenfield
Mr. & Mrs. Henry H. Rothschild
Mr. & Mrs. David W. Ruttenberg
Mr. & Mrs. Ted Ruwitch
Alan & Esther Saks
Mr. & Mrs. Robert E. Samuels
Mrs. Morton G. Schamberg
G. D. Searle & Co./
Mr. & Mrs. Donald Rumsfeld
Mr. & Mrs. Ned Schechter
Max Schiff, Jr.
Mr. James H. Schink
Mr. & Mrs. Herschel L. Seder
Mr. & Mrs. George Segal
Mr. & Mrs. Earl W. Shapiro
Mr. & Mrs. Joseph R. Shapiro

Mr. & Mrs. Gerald K. Silberman
Mr. Victor Skrebneski
Mr. & Mrs. Edward B. Smith, Jr.
Mr. & Mrs. Irving Solomon
Mr. & Mrs. Jerold Solovy
Mr. & Mrs. Philip Spertus
Mr. & Mrs. Modie J. Spiegel
Dr. Carol Stein
Marcia & Irving Stenn, Jr.
Mr. & Mrs. Paul Stepan
Mr. John Stern
Dr. & Mrs. Paul Sternberg
Mr. & Mrs. Clement Stone
Howard & Donna Stone
Mr. Jerome H. Stone
Dr. & Mrs. Michael Roy Treister
Ms. Susan Trevelyan-Syke
Mr. & Mrs. Allen M. Turner
Mr. & Mrs. Robert C. Vagnieres
Mr. & Mrs. Harvey M. Walken
Barbara & Harvey Walner
Mr. & Mrs. Irwin Ware
Shirley G. Warshauer
Mr. & Mrs. Gerald A. Weber
Mr. & Mrs. Judd A. Weinberg
Mr. & Mrs. Max Hess Weinberg
Jeanne M. Weislow
Mr. & Mrs. Edward H. Weiss
Mrs. Benton J. Willner
Mr. & Mrs. Herbert J. Winter
Mr. & Mrs. Robert E. Wood II
Mr. & Mrs. John Zeisler
Mr. & Mrs. John Zenko
Mr. & Mrs. Nat Zivin